IMAGES
of America

HANAHAN

IMAGES
of America

HANAHAN

B. Earl Copeland and Christie Rainwater

ARCADIA
PUBLISHING

Published by Arcadia Publishing
Charleston, South Carolina

Printed in the United States of America

Library of Congress Control Number: 2023933073

For all general information, please contact Arcadia Publishing:
Telephone 843-853-2070
Fax 843-853-0044
E-mail sales@arcadiapublishing.com
For customer service and orders:
Toll-Free 1-888-313-2665

Visit us on the Internet at www.arcadiapublishing.com

The Hanahan community has shared family values to create the small-town feel that we hold so dear. We dedicate this book to all those of the past who have shared their memories and experiences, and to those in the future to continue in this spirit of the city.

CONTENTS

ACKNOWLEDGMENTS

The authors wish to acknowledge some of the people who went above and beyond in assisting in gathering the materials for this history. We called upon them time after time for information and leads; they are as follows: former Goose Creek mayor Michael J. Heitzler; Hanahan mayor pro tempore Michael Sally; Roger Templeton of Berkeley County Geographic Information System (GIS); Charleston Water Systems; Bobbi (Blackwell) Bartee; Rosemary Hutchinson; Jestine Campbell; Lisa (Copeland) Coulter; Joan Turner; former Hanahan mayor Larry Cobb and his wife, Maureen Cobb; former Hanahan mayor Minnie Newman; Doug Rogers; Hazel Kreider Sawyer; Chad Chinners; Stuart Nuckolls; Anne Steele Farley; Debbie Lewis; Linda Brown; Lonnie Cowart; Joshua Mayes; Jessica Schuman; Lynn Brown Mercer; Martha Trussell; and Betty Jacques Wickert.

We also wish to express our gratitude to each person who took time to locate a piece of history through a photograph.

We want to especially recognize our families who have been supportive during these many months of tedious work. Earl's wife, Nadine (Walton) Copeland, lovingly gave him time and space to research and write out much of this history. Christie's husband, Mark, and four children, Caleb, Daniel, Haley, and Zachary, allowed her the time to put the book together and also shared in the fun around the dining room table at times. Without their support, this book would not be possible. Below is a key to the photograph contributors:

Adam Spurlock (AS)
Anne Steele Farley (ASF)
Berkeley County supervisor (BCS)
Bob Call (BC)
Berkeley County GIS Mapping Department (BCGIS)
Berkeley County Register of Deeds, Cynthia Forte (BCRD, CF)
B. Earl Copeland (BEC)
Bryce Florie (BF)
Aldersgate United Methodist Church, Betty Jacques Wickert (BJW)
Britt Reames (BR)
Bill Trapp (BT)
Chad Chinners (CC)
Christie Rainwater (CHR)
Charleston Museum (CM)
Carl E. Meynardie" (CMJR)
City of Hanahan (COH)
Catherine Sompayrac Giles (CSG)
Charleston Water System (CWS)
Donald Eugene Roberts (DER)
Debbie Lewis (DL)
Doug Rogers (DR)
Divine Redeemer Catholic Church (DRC)
Elizabeth "Betsy" Dyches (EBD)
George Brisco (GB)
George "Barry" Barrineau Jr. (GBJ)
Pastor G.L. Brown (GLB)

Hazel Kreider Sawyer (HKS)
Herb Spencer (HS)
Joe McKeown (JMK)
Joan Turner (JT)
Kristy Copeland Owen (KCO)
Kathy Lewis Williams (KLW)
Kathy Williams-Wright (KWW)
Mrs. Billye Brown (MBB)
Michael Heitzler (MH)
Michael J. Sally (MJS)
Maureen McDonagh Cobb (MMC)
Pastor Craig Versprille (PCV)
Pastor LaShaun Flagg (LRF)
Pat Martin (PM)
Phillip Farley (PF)
Rock Bradham (RB)
Roxy Dyches Kinsey (RDK)
RoseMary Hutchinson (RMH)
Reverend Robert Tilton (RRT)
South Carolina Department of Archives and History (SCDAH)
Stephanie Meynardie Stoudemayer (SMS)
Stuart Nuckolls (SN)
Steve and Pam Parker (SPP)
Vernon and Edith Black (VEB)
Walter Carr (WC)
Yeamans Hall Club, Brian Boss (YHCC, BB)
Yeamans Park Presbyterian Church (YPPC)

INTRODUCTION

While there are many beautiful and historic towns and cities across South Carolina and America with much longer histories than Hanahan, what makes this city unique is the sense of community. Hanahan, the city, is very young in years, having only incorporated in September 1973; it will celebrate its 50th anniversary in September 2023. Although it was not planned that way, the release of this book coincided with the celebration of Hanahan's golden jubilee.

Hanahan, as a place centrally located on the map of the Charleston region, is steeped in history that reaches back long before its incorporation. It is located within a 20 minutes' drive to old Charles Town, on the Ashley River, where some of America's earliest European settlers arrived in the New World. Our easternmost city boundary touches on the Cooper River, which flows to meet the Ashley River, forming Charleston Harbor. Within the city boundaries, there were major parts of four working plantations during the 17th, 18th, and part of the 19th centuries and two or three others with smaller tracts within the city limits.

The colonial period, from 1660 to 1750, was a time of great expectations for the restless European adventurers looking to expand their horizons around the world. England's King Charles II gave land grants to eight of his loyal friends, known as the Lords Proprietors, in 1663, but it was several years before the community of Charles Town, named for the king, was established. John, Lord Berkeley, for whom Berkeley County, South Carolina, was named, was one of the eight.

In 1665, Sir John Yeamans, for whom Yeamans Hall Plantation was named, was commissioned as governor of Clarendon County, along the Cape Fear River in what is now North Carolina. However, the county was destroyed by a very large hurricane, and the newly established community was abandoned. Sir Yeamans later settled in the new Charles Town area on land received in a land grant, at the confluence of the Cooper River and Goose Creek tributary.

In the early 1700s, the colonists who settled in Charles Town began to push away from the coast, looking for new opportunities north of the new town. Brothers Sir Edward and Sir Arthur Middleton arrived in Carolina with the early immigrant families. They received land grants on the Ashley River and farther inland, part of which is in Hanahan and encompasses the plantation first named Yeshoe and later called Otranto. The name has been known to reference either an Italian port in southern Italy, which Alexander Garden, for whom the gardenia flower was named, may have visited as he served as a naval surgeon in 1749 or 1750, or Horace Walpole's Gothic novel published in 1764 by the title *The Castle of Otranto*.

In the earliest days of the colonial period, there was only one Carolina. It was many years later that it was divided into North and South Carolina. In 1669, the Lords Proprietors named William Sayle as governor of the part of Carolina south of Carteret, North Carolina. He set sail from England, and weeks later, he landed on the Ashley River with 150 souls onboard, the first Europeans to settle on the coast of what was to become South Carolina.

Over the next 150 years, South Carolina's Lowcountry flourished as an agricultural society. The plantations of that period served as the foundation of all foreign trade and exports that drove the economy of the fledgling colonies. When the South was defeated in the American Civil War and the slaves were freed, it brought an end to the plantation economy. The plantations were broken up into many small farms, which gave average citizens an opportunity to own land and produce food and an income for their families.

From the early 1900s, Hanahan began to develop as a community. Then, following World War II, this area, which is near Charleston Air Force Base and Charleston Navy Base, saw unprecedented growth. Being landlocked by the city of North Charleston and the city of Goose Creek, much future growth is unlikely though. Our city is small enough that our children are educated together in the same elementary through high school. Hanahan is home to over a dozen churches, of many Christian denominations. Much of our family social life is centered around our churches and schools, thus accounting for our closeness as a community.

We have so many qualities that recommend Hanahan as a very desirable place to live and raise a family; we are centrally located in the Lowcountry of South Carolina and are able to travel a short distance to beautiful beaches, shopping, and so many other amenities. We are close enough to be able to enjoy the beautiful mountains of the Carolinas. We have great seasonal weather that prevents us from getting cabin fever, but seasons are short enough not to become monotonous. Hanahan is known for its good schools, and we are near some of the best hospitals in the country. Hanahan is truly the heart of the Lowcountry.

One

ANTEBELLUM

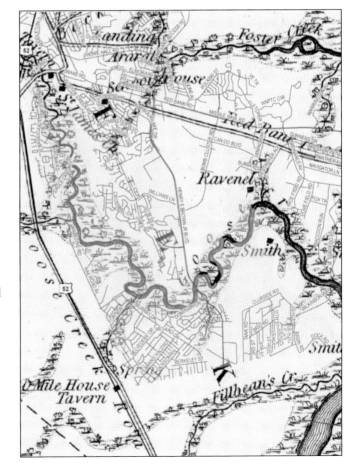

This 1825 Mills Map has been overlaid with the city of Hanahan's current street map using Goose Creek Road (Highway 52) and Red Bank Road as guides. The old 1825 Mills Map was not as precise as the current maps, and therefore, the boundaries did not match up exactly. These maps that have been married together paint the picture of the Hanahan that once was with the Hanahan that is now. (BCGIS.)

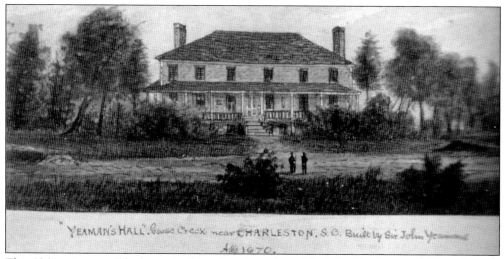

This 1864 painting of the house built on the plantation of Sir John Yeamans in 1670 is the only known image of the original plantation house. Sir John Yeamans was born in England and, eventually, became governor of Carolina. There are conflicting accounts about exactly who built the house. One account says that the bricks were shipped from England to Charleston. Union private Robert Knox Sneden, the artist, was part of a Civil War prisoner exchange that took place at Charleston Harbor. Private Sneden's group was marched from the Confederate prison at Andersonville, Georgia, and bivouacked at Yeamans Plantation, awaiting the exchange. The house was heavily damaged in the 1886 Charleston earthquake and was later destroyed by fire. After Sir Yeaman's death, the property remained briefly in the family of his widow, Lady Margaret Yeamans. It was then transferred to Landgrave Thomas Smith, in whose family it remained for nearly two centuries. Some accounts credit Thomas Smith as having built the original plantation home. (YHC, BB.)

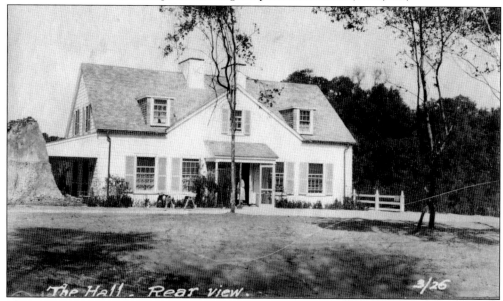

The view of this 1926 photograph is from the rear of this home at Yeamans Hall Country Club. Note the ruins at the left in this photograph of the original chimney of the Yeamans Plantation house, built in the late 1600s by Sir John Yeamans. Over the decades, those ruins further deteriorated and were later removed. (YHC, BB.)

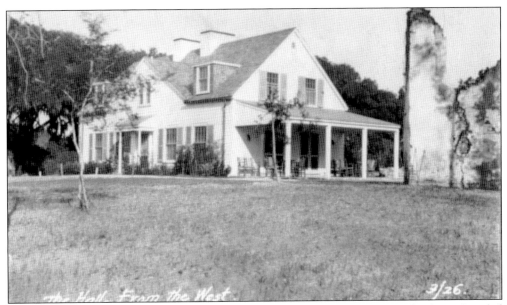

During the decadent Roaring Twenties, a group of wealthy New York bankers and industrialists, led by Thomas Lamont Jr., bought the run-down tract of land on the southwest confluence of Goose Creek and Cooper River that once was the thriving Yeamans Plantation during the 18th and 19th centuries. They hired famous golf course designer Seth Raynor to design the new playground that would become one of the most famous golf courses in the world. This photograph of "the Hall," taken in 1926 shortly after the club was formed, shows the best view of the ruins that remained at that time from the original Yeamans Plantation house. (YHC, BB.)

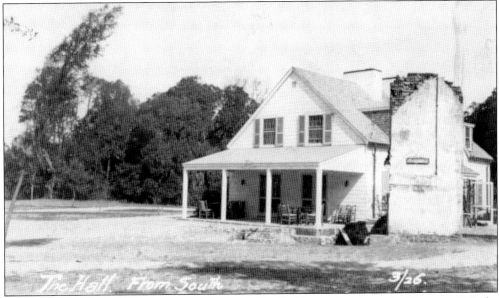

According to Charlton deSaussure Jr. in his book *The Golf Course and Grounds of Yeamans Hall*, the group who formed Yeamans Hall Country Club initially planned to build 250 homes and another golf course in the region. However, the Wall Street crash of 1929 and the following economic collapse in America brought a halt to those plans. Only 35 houses were ever built. In this 1926 photograph is a view of the hall from the south. (YHC, BB.)

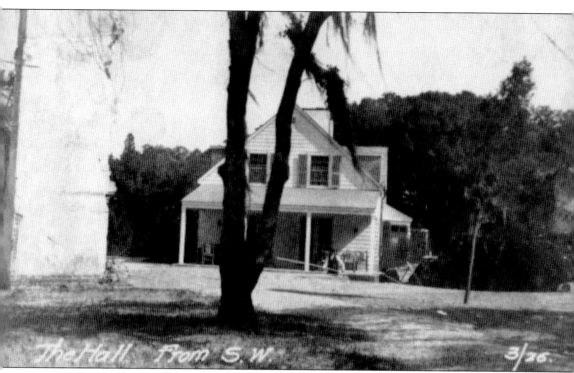

The Hall from S. W. 3/26.

According to Charlton deSaussure Jr., Seth Raynor, who designed the golf course at Yeamans Hall Plantation, began his work on the plan in 1923. His first visit to Charleston to begin staking out the course was in April 1923. The construction of the course was completed in 1925. This photograph, taken in March 1926, shows the hall with the adjacent ruins from the southwest. (YHC, BB.)

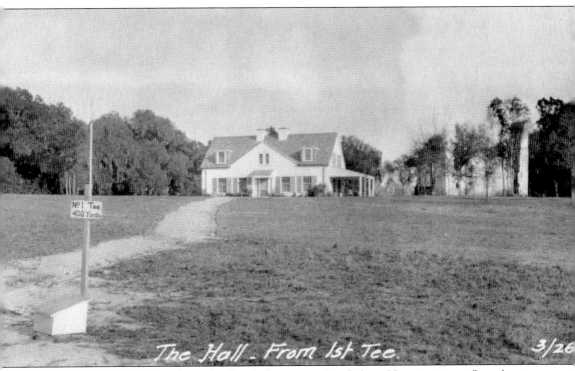

The Hall - From 1st Tee. 3/26

In 1924, Frederick Olmsted Jr., who first had a vision of an "admirable winter resort" on the site of the former plantation in 1915, visited the new Yeamans Hall Country Club under construction. According to Charlton deSaussure Jr., Olmsted wrote a letter to the club organizers in which he talked in glowing terms of the plan and the beautiful views of the course. This photograph of the hall, taken from the first tee, shows its beauty along with the historic remains of the original Yeamans Plantation house. (YHC, BB.)

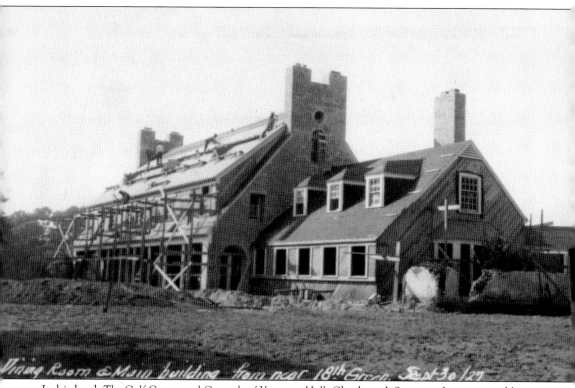

Dining Room & Main building from near 18th Green Sept 30/27

In his book *The Golf Course and Grounds of Yeamans Hall*, Charlton deSaussure Jr. recounted how, in his 1915 letter, Frederick Olmsted Jr. laid out his vision of his proposed "winter resort." He envisioned an English-style hotel nestled among the grand oaks of Yeamans Hall. The Olmsted brothers were hired by Thomas Lamont Jr. and his group over a decade later to draw the master plan for the resort. Pictured here in September 1927 is the hotel-turned-clubhouse being constructed. It has a spacious reception area upon entering the front door, with two dining rooms and a kitchen. It also has a library and a card room on the first floor. The second floor contains eight guest bedrooms and baths. (YHC, BB.)

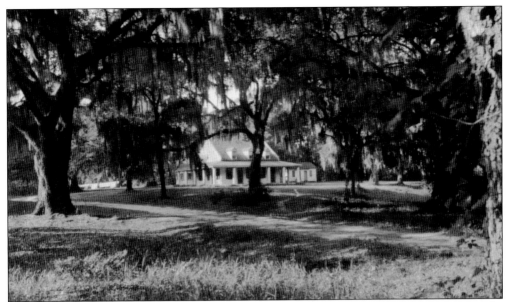

Through a land grant, brothers Arthur and Edward Middleton acquired land that would later be known as Otranto Plantation. It was one of the first plantations in the Lowcountry, and 1678 is its earliest-known date of existence. Through several owners, the plantation held its Native American name Yeshoe until 1771, when it was purchased by botanist Alexander Garden, for whom the gardenia was named. He renamed the estate Otranto. In 1934, a fire left the house badly damaged. A restoration of the home took place using old photographs to bring it back to its original likeness on the exterior while completely redoing its interior. In the early 1900s, Otranto Plantation was used as a hunting club, but in 1965, a local developer, Andrew J. Combs, bought the property and developed the Otranto subdivision. (Above, MH; below, CM.)

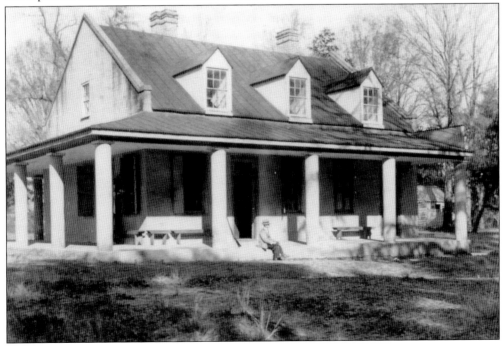

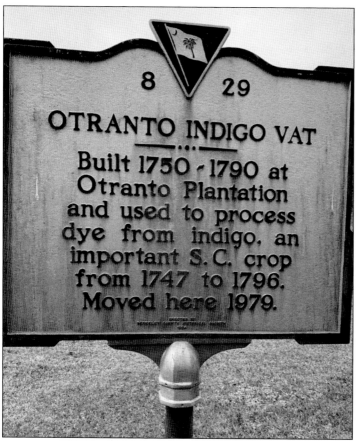

8 ▽ 29

OTRANTO INDIGO VAT
—···—
Built 1750 - 1790 at
Otranto Plantation
and used to process
dye from indigo, an
important S. C. crop
from 1747 to 1796.
Moved here 1979.

The Otranto Plantation was known for its two cash crops of rice and indigo. Both crops were exported back to England. The indigo was used for dying the clothing of the European nobility. (BEC.)

As Otranto was developed into a subdivision, three vat systems were discovered. One of the three systems was able to be saved. The historical significance of the vats was noted by a dye maker, the Verona Chemical Company, later renamed the Mobay Corporation, and they were purchased and relocated to its plant site on the Cooper River in Berkeley County on Bushy Park Road. The vats can be seen by the public today. (BEC.)

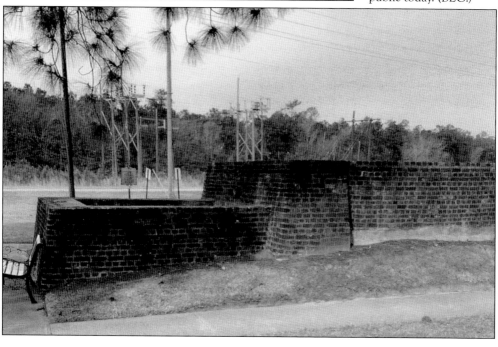

United States Department of the Interior
National Park Service

NOV 2 0 1989 2150

National Register of Historic Places
Registration Form

This form is for use in nominating or requesting determinations of eligibility for individual properties or districts. See instructions in *Guidelines for Completing National Register Forms* (National Register Bulletin 16). Complete each item by marking "x" in the appropriate box or by entering the requested information. If an item does not apply to the property being documented, enter "N/A" for "not applicable." For functions, styles, materials, and areas of significance, enter only the categories and subcategories listed in the instructions. For additional space use continuation sheets (Form 10-900a). Type all entries.

1. Name of Property

historic name Otranto Plantation Indigo Vats
other names/site number

2. Location

street & number SC Sec Rd 503 at entrance to Mobay Corp. ☐ not for publication
city, town Goose Creek ☒ vicinity
state South Carolina code SC county Berkeley code 015 zip code 29411

3. Classification

Ownership of Property	Category of Property	Number of Resources within Property		
☒ private	☐ building(s)	Contributing	Noncontributing	
☐ public-local	☐ district	____	____	buildings
☐ public-State	☐ site	____	____	sites
☐ public-Federal	☒ structure	1	____	structures
	☐ object	____	____	objects
		1	0	Total

Name of related multiple property listing:
N/A

Number of contributing resources previously
listed in the National Register 0

4. State/Federal Agency Certification

As the designated authority under the National Historic Preservation Act of 1966, as amended, I hereby certify that this ☒ nomination ☐ request for determination of eligibility meets the documentation standards for registering properties in the National Register of Historic Places and meets the procedural and professional requirements set forth in 36 CFR Part 60. In my opinion, the property ☒ meets ☐ does not meet the National Register criteria. ☐ See continuation sheet.

Signature of certifying official *Mary W. Edmonds* Date 11/8/89
Mary W. Edmonds, Deputy SHPO, SC Department of Archives & History
State or Federal agency and bureau

In my opinion, the property ☐ meets ☐ does not meet the National Register criteria. ☐ See continuation sheet.

Signature of commenting or other official Date

State or Federal agency and bureau

5. National Park Service Certification

I, hereby, certify that this property is:

☑ entered in the National Register.
 ☐ See continuation sheet.
☐ determined eligible for the National
 Register. ☐ See continuation sheet.
☐ determined not eligible for the
 National Register.

☐ removed from the National Register.
☐ other, (explain:) _____

Entered in the
National Register

Signature of the Keeper 12/2/89
Date of Action

This National Register of Historic Places Registration Form was submitted by Mary W. Edmonds of the South Carolina Department of Archives and History in 1989. The documents submitted share the process of the manufacturing of the indigo dye. After going through the fermentation and settlement process, the liquid was extracted, and the remains were formed into dried cakes to be shipped. (SCDAH.)

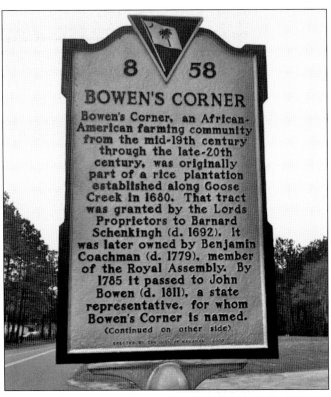

8 ∇ 58

BOWEN'S CORNER

Bowen's Corner, an African-
American farming community
from the mid-19th century
through the late-20th
century, was originally
part of a rice plantation
established along Goose
Creek in 1680. That tract
was granted by the Lords
Proprietors to Barnard
Schenkingh (d. 1692). It
was later owned by Benjamin
Coachman (d. 1779), member
of the Royal Assembly. By
1785 it passed to John
Bowen (d. 1811), a state
representative, for whom
Bowen's Corner is named.
(Continued on other side)

ERECTED BY THE CITY OF HANAHAN, 2008

Bowen's Corner Plantation was located on the east side of Goose Creek. The historical markers tell the history of the once thriving plantation. Today, descendants of those slave families still own and live on parts of the property along Foster Creek Road that their ancestors inherited from the plantation owners after they won their freedom following the Civil War. Other parts were sold by the heirs of those families to developers. Those developments include the communities of Tanner Plantation, Bowen Waterfront Village, and others along Foster Creek Road. (Both, BEC.)

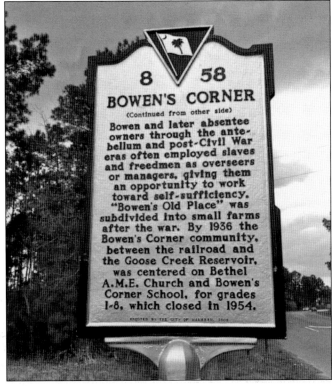

8 ∇ 58

BOWEN'S CORNER
(Continued from other side)

Bowen and later absentee
owners through the ante-
bellum and post-Civil War
eras often employed slaves
and freedmen as overseers
or managers, giving them
an opportunity to work
toward self-sufficiency.
"Bowen's Old Place" was
subdivided into small farms
after the war. By 1936 the
Bowen's Corner community,
between the railroad and
the Goose Creek Reservoir,
was centered on Bethel
A.M.E. Church and Bowen's
Corner School, for grades
1-8, which closed in 1954.

ERECTED BY THE CITY OF HANAHAN, 2008

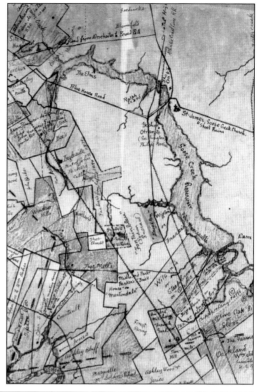

William Henry Johnson drew this map of the Goose Creek Reservoir and surrounding areas, and it is from his collection of plats. Since the Hanahan railroad station is notated on this map, it is estimated that this drawing was created sometime after 1917, when Ross Hanahan became chairman of the Commissioners of the Public Works of the City of Charleston. Prior to that time, the waterworks pumping station and railroad stop were known as the Saxon pumping station and Saxon railroad stop. (Both, MH.)

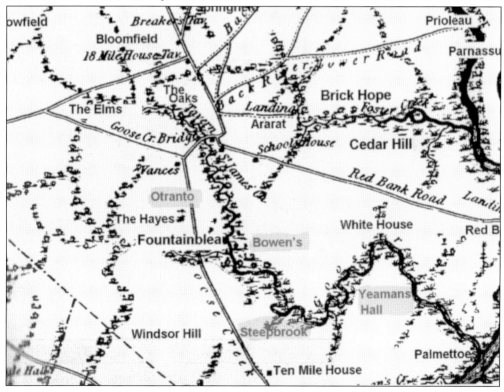

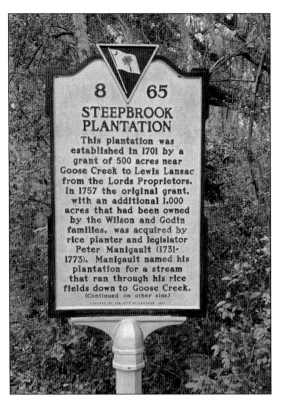

8 ∇ 65

STEEPBROOK PLANTATION

This plantation was established in 1701 by a grant of 500 acres near Goose Creek to Lewis Lansac from the Lords Proprietors. In 1757 the original grant, with an additional 1,000 acres that had been owned by the Wilson and Godin families, was acquired by rice planter and legislator Peter Manigault (1731-1773). Manigault named his plantation for a stream that ran through his rice fields down to Goose Creek.

(Continued on other side)

ERECTED BY THE CITY OF HANAHAN, 2010

This historical marker was placed by the City of Hanahan in 2010. It is located beside the entrance road off Railroad Avenue between Hanahan Elementary School and Hanahan Senior Citizens Center and gymnasium. Peter Manigault (1731–1773), who owned one of the plantations that was partly in present-day Hanahan, was the wealthiest person in the British North American colonies at the time of his death. Although the house that he built has been gone for many decades, this marker memorializes the once stately home of the planter/state legislator. The inscription on both sides of the marker best shows the history of the once thriving Manigault Plantation. (Both, BEC.)

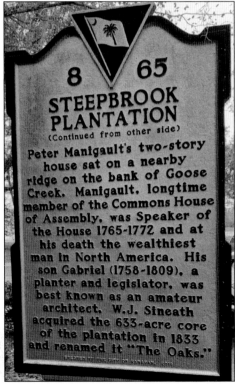

8 ∇ 65

STEEPBROOK PLANTATION

(Continued from other side)

Peter Manigault's two-story house sat on a nearby ridge on the bank of Goose Creek. Manigault, longtime member of the Commons House of Assembly, was Speaker of the House 1765-1772 and at his death the wealthiest man in North America. His son Gabriel (1758-1809), a planter and legislator, was best known as an amateur architect. W.J. Sineath acquired the 633-acre core of the plantation in 1833 and renamed it "The Oaks."

ERECTED BY THE TOWN OF HANAHAN, 2010

Two

HANAHAN BEGINNING

J. Ross Hanahan, for whom the city of Hanahan is named, was chairman of the Commissioners of the Public Works of the City of Charleston (1917–1923). He was born July 5, 1869, and died February 28, 1963, at the age of 93. Hanahan was a businessman and influential leader of the Charleston community for decades. He is buried at Magnolia Cemetery, the oldest perpetual care cemetery in South Carolina. His wife, Maria (Grayson) Ogier Hanahan, is buried beside him. (CWS.)

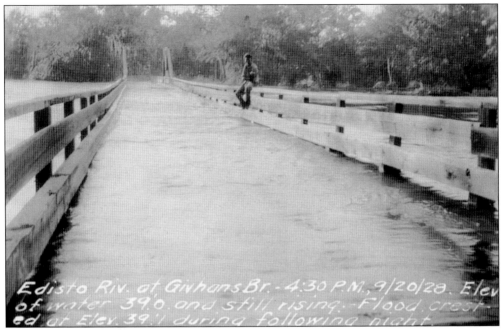

Starting at the Edisto River near Givhan's Ferry in Dorchester County, water travels 43 miles through tunnels, using both gravity and pumps, to reach the Hanahan water processing facility where it is processed. From there, it is distributed to homes, businesses, and industries throughout the region. (CWS.)

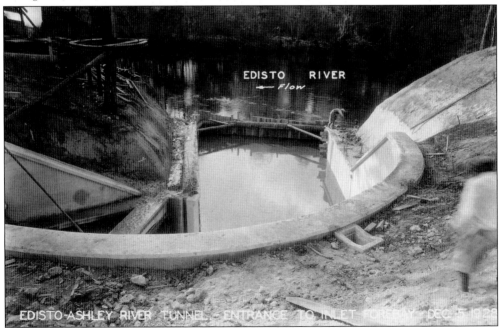

The design of the system that would move enough water from the Edisto River to the processing site in Hanahan was an engineering feat, not to mention the number and quality of the construction crews it took to build it. It required pump lift stations all along the route. Pictured is the tunnel entrance on the Edisto River during construction on December 5, 1928. (CWS.)

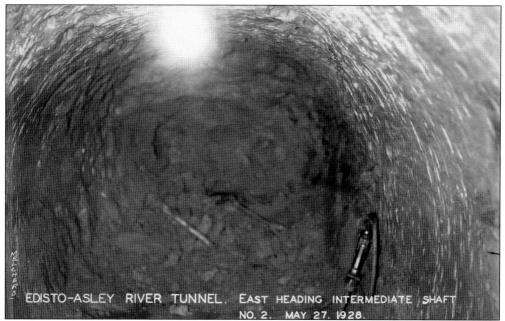

EDISTO-ASLEY RIVER TUNNEL. EAST HEADING INTERMEDIATE SHAFT NO. 2. MAY 27. 1928.

In the above photograph, note the two shovels and the electric light. Digging the tunnel was labor-intensive work. The tunnel was dug through a thick layer of marl, which is a clay-like layer of earth several feet below the surface that becomes as hard as concrete when in contact with water. Many crews worked all along the route simultaneously. According to the inscription on the photograph, this view was looking west from Intermediate Shaft No. 2 and was taken on May 27, 1928. The construction of the shafts, however, required concrete to prevent the walls from caving in. (Both, CWS.)

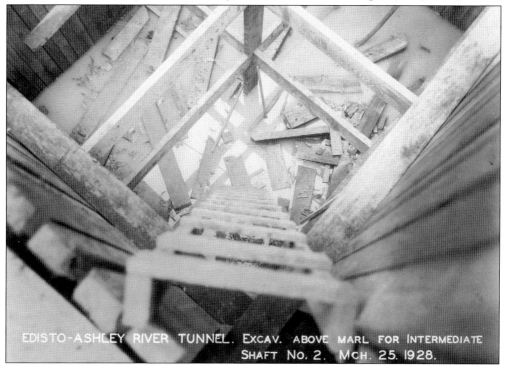

EDISTO-ASHLEY RIVER TUNNEL. EXCAV. ABOVE MARL FOR INTERMEDIATE SHAFT NO. 2. MCH. 25. 1928.

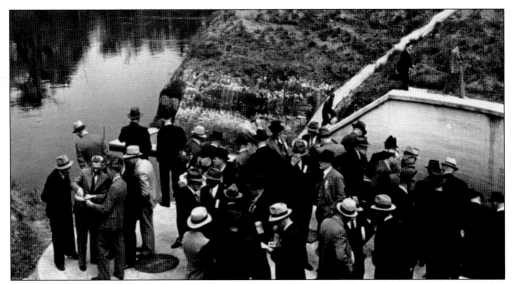

The Charleston Water Commission and community leaders gathered at the source of the new water supply, the Edisto River, which flows through Dorchester County. The concept of moving vast amounts of fresh water over dozens of miles in order to supply a growing city was relatively new in the early 1900s. In those days, it was an extremely labor-intensive process. (CWS.)

Charleston Water System has provided potable water to the citizens of Charleston since 1917, when the Charleston City Council created the commission to manage the city's drinking water supply. The original Hanahan Pumping Station, built in 1903, is now the site of Charleston Water System's Water Treatment Plant. What started out as a source for drinking water for the residents of the City of Charleston is now the source for drinking water for towns throughout the Charleston area, including Hanahan. Some commission members are inspecting the progress on June 15, 1928, in the early days of the Edisto tunnel development. (CWS.)

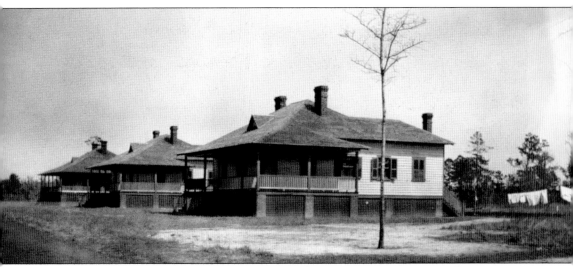

The first houses built following the establishment of the waterworks were adjacent to the community of Highland Park and the CSX Railroad, formerly Atlantic Coast Line (ACL) Railroad. These three houses were built by the Commissioners of the Public Works of the City of Charleston, commonly known as CPW or waterworks, for its engineer and operators who lived on-site. In the 1940s, Lee Kreider (later Simpson), the daughter of Elmo and Grace Kreider, the first family to build a home in Highland Park, became friends with Ouida Shipley, daughter of Charles Guy Shipley, chief engineer of CPW. The last surviving of five Kreider sisters, Hazel, remembers visiting a Mrs. Shipley as a child with her mom in one of those houses. (CWS.)

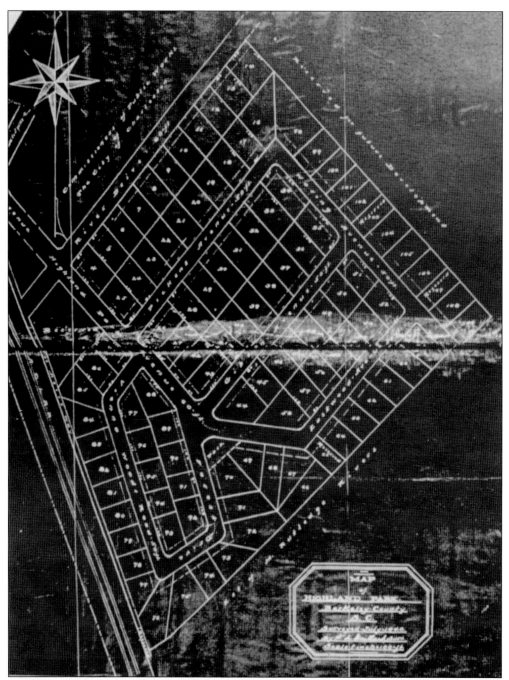

Leading up to World War II, Charleston began to rapidly expand because of the large military presence in the area. One of the many businessmen who recognized the opportunity that presented was George Rivers Fishburne, an 1897 Citadel graduate, a prominent Charleston real estate developer, and a cousin of Congressman L. Mendel Rivers. Fishburne purchased a large tract of land adjacent to the ACL Railroad in Berkeley County and the Commissioners of the Public Works of the City of Charleston. There, he laid out the first planned development in what was to become the city of Hanahan. In July 1940, he filed this plat with the Berkeley County Clerk of Court. (BCRD, CF.)

One of the first homes built in Highland Park was completed in the summer of 1941. The Kreider home located at 27 Highland Park Avenue has provided a glimpse back in time. Above, Elmo Kreider posed for a picture with two of his three daughters, Virginia at age one and Rita at age nine. The detached garage was added a few months after the home was finished. Below, on the front steps are Rita and a neighborhood friend. The home still remains, although the house number changed in the 1970s to 1206 Highland Park Avenue. (Both, BEC.)

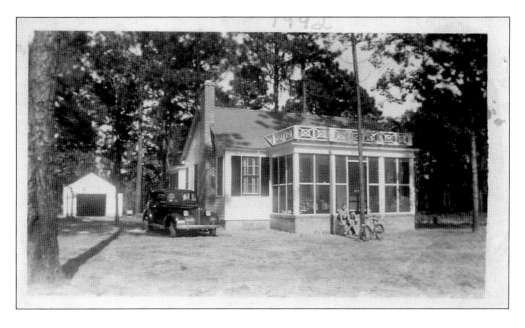

According to their granddaughter Kathy (Lewis) Williams, Albert and Rachel Bullwinkel, pictured here, first purchased the acreage on the bank of Goose Creek adjacent to the waterworks in 1938 from George R. Fishburne. Her granddaddy's family owned Bullwinkel Bakery in downtown Charleston. The Bullwinkels left the property to their daughter Henrietta, who married George Lewis. George later became chairman of the Hanahan School Board. After George's death, the property is still in the Lewis family. (KLW.)

Albert and Rachel Bullwinkel continued to live in downtown Charleston after purchasing the property in 1938. They did not move to the Hanahan property until the early 1940s, when their daughter Henrietta was in elementary school. Just when the old Bullwinkel house was built is not clear. The granddaughter said that the house was already built when her grandparents bought the property, and that it was originally built on piers. Her granddaddy closed it in and made a downstairs living space. (KLW.)

Three

POST–WORLD WAR II

Zane Grey Nuckolls (April 23, 1922–March 1, 2004), pictured on the birthday cake, grew up in the mountains of Furches, North Carolina, in the early 1900s and the Roaring Twenties. He served in World War II. After returning from the war, in 1949, his cousin Kurt Taylor, who lived in Charleston, came to see him in North Carolina. Taylor told him that the Army was getting ready to sell the old Army base off Remount Road. At first, Nuckolls was not interested, but after reflecting on the cold winters in the mountains of North Carolina, he did some research and decided that Charleston's weather was much better. (WC, SN.)

After his Charleston cousin's visit to see them in North Carolina, Grey Nuckolls and his wife, Murial, made a trip down to Charleston where they bought the property on Dickson Avenue off Remount Road where he opened three businesses: the Arcadia Club, a skating rink, and a bowling alley. In this photograph, Nuckolls is standing in front of the USS *Yorktown* where he attended the 2002 World War II veterans recognition ceremony held by Congressman Henry E. Brown Jr. (SN, WC.)

After having opened and operated the three businesses in North Carolina prior to buying property and moving to Charleston in 1949, Grey Nuckolls first opened the Arcadia Club in the old Army Officers Club. On June 16, 1951, he opened the club, which had a dance floor, snack bar, and soda fountain. Admission was 50¢ per person. Opening night featured a popular dance band, the Palmetto Boys. The original grand opening flyer shares the details. The following Friday night, the club presented Buddy Shaw and his orchestra and produced another flyer for advertisement. The first week was so successful that the price was raised to 75¢ per person. Nuckolls did not permit alcoholic beverages. (Both, WC, SN.)

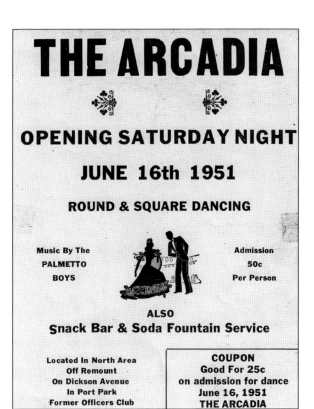

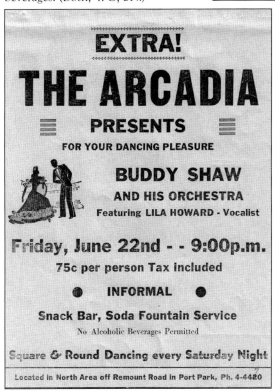

THE ARCADIA

Port Park, off Remount Road

Dial 4-4470

◆◆◆◆◆◆◆◆◆◆◆◆◆◆◆◆◆◆◆◆◆◆◆◆◆◆◆◆◆◆◆◆◆◆◆

The ARCADIA will be open every night at 6:30 EXCEPT SUNDAY

Round and Square Dance every Saturday Night

Snack Bar and Soda Fountain Service

No Alcoholic Beverages Permitted

◆◆◆◆◆◆◆◆◆◆◆◆◆◆◆◆◆ ◆◆◆◆◆◆◆◆◆◆◆◆◆◆◆◆◆◆◆◆

Is Proud to Announce

The Opening of the ARCADIA BOWLING

ALLEYS, Friday Night, Oct. 5, 1951

Duckpins and Tenpins 25c per line

◆◆◆◆◆◆◆◆◆◆◆◆◆◆◆◆◆◆◆◆◆◆◆◆◆◆◆◆◆◆◆ ◆◆◆◆◆◆◆◆◆

BOWLING

On October 5, 1951, Nuckolls expanded his business enterprise on the site, which he then named the Arcadia Center. The opening of the bowling alley was announced through this flyer. According to a document obtained from Walter Carr, who now owns the building, Nuckolls stated that Raymond Floyd and Ralph Swindal later bought the structure and added more bowling alleys. (WC, SN.)

In the late 1940s, after returning from World War II, Grey Nuckolls had run a skating rink where he grew up in the mountains of North Carolina. On Saturday November 24, 1951, he opened the Arcadia Rollerdrome in "Port Park off Remount Road." Most of Hanahan's youth of the 1950s, 1960s, and 1970s grew up spending untold hours skating there. The original flyer was announcing the new skating rink in what was to later become the city of Hanahan. Nuckolls eventually sold the business to the Walton family. (WC, SN.)

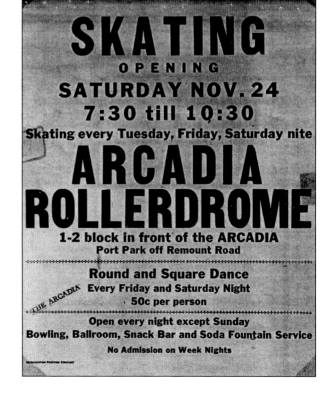

SKATING

OPENING

SATURDAY NOV. 24

7:30 till 10:30

Skating every Tuesday, Friday, Saturday nite

ARCADIA ROLLERDROME

1-2 block in front of the ARCADIA

Port Park off Remount Road

Round and Square Dance

Every Friday and Saturday Night

50c per person

Open every night except Sunday

Bowling, Ballroom, Snack Bar and Soda Fountain Service

No Admission on Week Nights

Following the end of World War II, the Army closed the base and prisoner of war camp on Remount Road and Dickson Avenue, now part of Hanahan. The government sold the old barracks to individuals for housing needs. Among those families were the Hutchinson family, pictured here. (RMH.)

Robert "Bob" Hutchinson was from Effingham, South Carolina, and Gertrude Rita (Brumm) Hutchinson was from Brooklyn, New York. They had three boys and a girl. Bob Hutchinson was a construction iron worker, employed with a contractor at the paper mill or navy base. This photograph is of the family reroofing the old barracks before moving on to the other renovations that would turn an old building into a modern home suited for a growing family. This was a family project, which included the youngsters. (RMH.)

The property at 1261 Dickson Avenue was purchased in March 1949. The Hutchinson family moved into the tar-papered barracks shortly after the purchase, and they renovated the interior as they went along. RoseMary, their daughter, remembers there was a potbellied coal stove in the hall for heat. Her mother bathed them in a very large, two-basin galvanized sink that served multiple purposes; it was used for bathing the kids and doing laundry until a wringer washer was installed on the side porch. At first, they had to use outdoor latrines that were next door, so installing a bathroom was a first priority. (RMH.)

Four

SCHOOLS, CHURCHES, AND CIVIC COMMUNITY

In 1949 or 1950, George R. Fishburne conveyed property to Berkeley County for the express purpose of building a school. In the deed, he stated that if it was ever not used for that purpose, the property would revert back to the Fishburne family. When the new Hanahan Elementary School was built, in order to keep the ownership, Berkeley County School District officials decided to repurpose the old Fishburne Elementary School to become the Fishburne Education Center. The center is used to house Head Start and adult continuing education programs. (GB.)

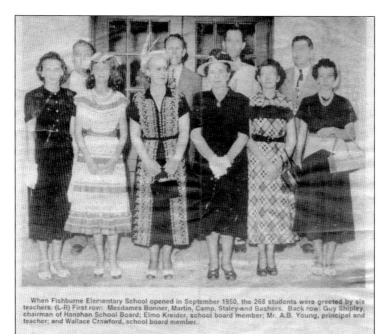

When Fishburne Elementary School opened in September 1950, the 268 students were greeted by six teachers. (L-R) First row: Mesdames Bonner, Martin, Camp, Staley and Bashers. Back row: Guy Shipley, chairman of Hanahan School Board; Elmo Kreider, school board member; Mr. A.B. Young, principal and teacher; and Wallace Crawford, school board member.

Printed in the *Hanahan News* in 1986, this 1950 photograph shows the new Hanahan School Board members, the principal, and the teaching staff. Guy Shipley was chief engineer of the CPW and lived in one of the houses constructed on the waterworks property adjacent to Highland Park. Elmo Kreider, father-in-law of coauthor B. Earl Copeland, and Wallace Crawford were both employed by the Charleston Naval Shipyard. (HKS.)

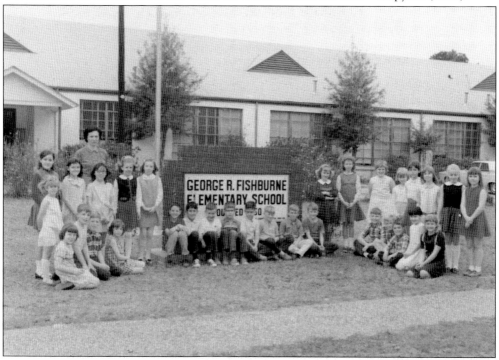

In the early days of Fishburne Elementary School in the 1950s and 1960s, class sizes were very large. As an indicator, the first Fishburne Elementary school year in 1950 had only six teachers for 268 students, an average of 44 students per teacher. By the mid-1960s, class sizes were down a little but still large as compared to today. Hazel Funderburkes's fourth-grade class, shown here, and Mrs. Heath's first-grade class, pictured on the cover of this book, showed that each class was made up of over 30 students. Despite that, they seem to be well behaved. (BT.)

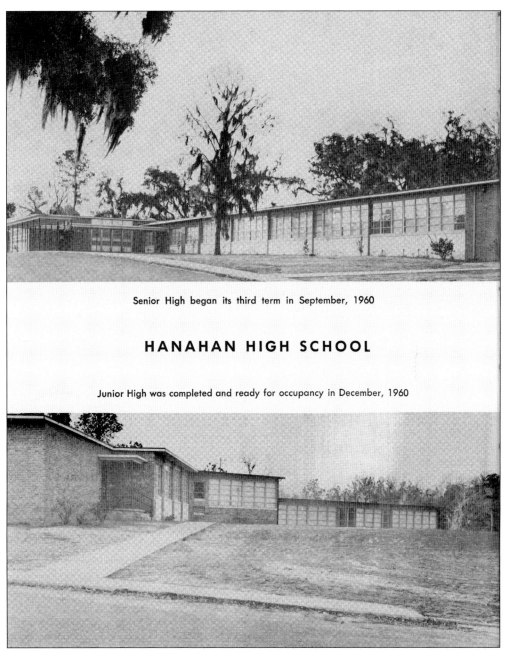

Senior High began its third term in September, 1960

HANAHAN HIGH SCHOOL

Junior High was completed and ready for occupancy in December, 1960

Initially, Hanahan High School and Hanahan Junior High School were constructed and first occupied in September 1958. After Hanahan Middle School was later built farther down Murray Avenue, Hanahan Junior High School then became part of the expanded high school. The Stevenson-Zimmerman Company owned the large tract of land that now comprises Belvedere Estates and Hanahan High School in the late 1950s. The company sold the dirt in that tract to build Interstate 26. T.A. Bonner and Rev. Ray Smith bought the property, built a sewer pumping station, and constructed the Belvedere subdivision. They sold 20 acres bordering Murray Drive to the school district to build Hanahan High School. Hanahan High School's first principal was T.J. Bratton, followed in 1960 by R.H. Wallace. (BEC.)

Senior Hill is located behind Hanahan High School and has been around as long as the school, since 1958. While looking at the hill some may say it is just a pretty hill with some beautiful trees, a nice grassy knoll, and some benches, but it is safe to state that every Hanahan High School student has a story about Senior Hill. Alumni can easily think back to a classic and fun senior prank that was related to Senior Hill. There was an unspoken rule that "only seniors are allowed on the hill." If an underclassman was caught there, he was subject to being rolled down the hill in a barrel. Pictured is a group of students on the hill during homecoming week in 1987. (MJS.)

Hanahan has always been known for its excellent schools. There is a long list of leaders, teachers, and staff who have made excellence the standard and continue to do so to present day. Pictured is a photograph of two of Hanahan High School's longest-serving staff, Dan Gross (left), who led as principal from 1969 to 1993, and Mildred Dyches (right), lunchroom manager from 1967 to 1989. Staff and students alike loved these two. They were true leaders. (RDK.)

Like many high schools across America, Hanahan High School had a tradition of senior class trips to Washington, DC. Pictured here, the class of 1961 is with the South Carolina congressional delegation, Sen. J. Strom Thurmond, Sen. Olin D. Johnston, and Congressman L. Mendel Rivers, on the steps of the US Capitol. (RDK.)

The early years of Fishburne Elementary School were about more than just academics. Some of the parents, with approval of the school administration, developed extracurricular activities such as the annual maypole dance and coronation, pictured here in 1957 on the Fishburne Elementary School playground. Also, there were teen club dances organized and chaperoned by Lou Daniels. (Both, RMH.)

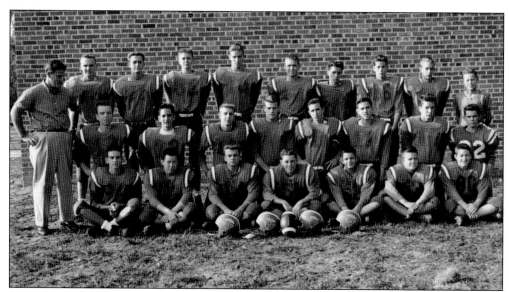

When Hanahan High School opened in 1958, there were neither ball fields nor a gymnasium. The football field was built using volunteers and was spearheaded by Wiley A. Knight Jr. The first head coach hired by Hanahan High School was Eddie Jones, pictured here with the first team to play on Wiley Knight Field for the 1958–1959 season. Coach Jones was assisted by coach Pascal Crosby. Cheering them on was the first Hanahan High School cheerleading team. (Above, RB; below, HKS.)

The high school athletic program started in 1958 with football, followed shortly thereafter by baseball and basketball. It has expanded over the years to include football, baseball, soccer, track and field, lacrosse, basketball, golf, tennis, softball, cross-country, wrestling, cheerleading, swimming, and the marching band. Pictured above is the 1969 Hanahan High School girls' basketball state championship team, coached by Hermine Smith, as well as a Hanahan boys' varsity basketball team in the 1970s below. (Above, MMC; below, HS.)

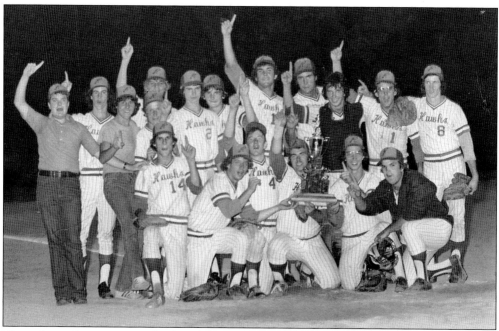

Throughout the years since the founding of Hanahan High School, the Hawks athletic teams have become highly competitive. Both boys' and girls' teams in most sports have won numerous conference and regional championships. A few have won lower state and state championships. The Hawks 1976 baseball team won back-to-back state championships in 1975 and 1976. (BT.)

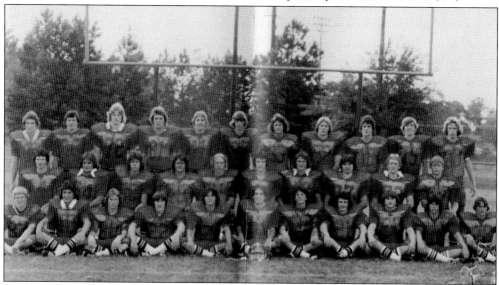

Hanahan High School has produced many notable athletes over the course of its history. Among them were many who received college athletic scholarships. Two of those were the Dyches brothers, Danny and Tim. Danny played college football and went on to the pros. His younger brother, Tim, seemed to be on track to follow in his brother's footsteps. Tim had a four-year scholarship to play football for the University of South Carolina and is featured in the University of South Carolina Hall of Captains; however, he had a motorcycle accident that cut his life far too short. Tim is No. 72 in this 1976 Hanahan Hawks team photograph. (RDK.)

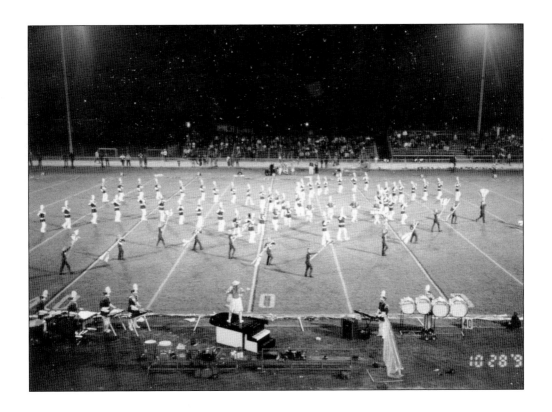

Hanahan High School's arts program has been one of the most successful areas of school pride and achievement and has consistently received local and statewide acclaim. A physically visible part of the music program has always been the Hanahan High School Marching Pride. Pictured below in this local article, its superior performance was acknowledged for winning eight straight lower state championships. (Both, SN.)

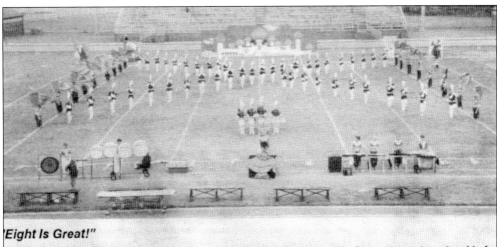

'Eight Is Great!"

"Eight is great" for the Hanahan Marching Pride Band as it captures the Lower State championship for he eighth year in a row! The Marching Pride Band has won the AA Lower State Championship trophy very year since the contest began. (See story on page 3-B)

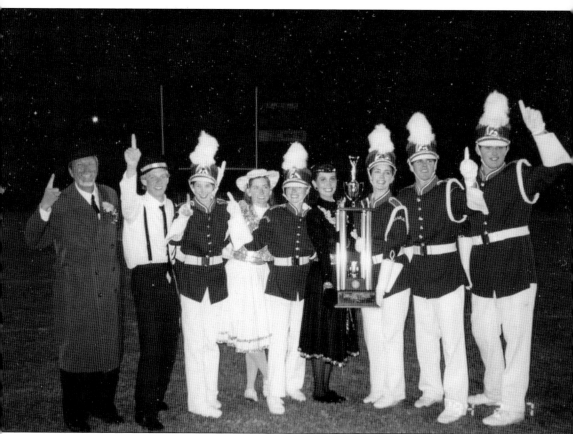

Year after year, the band won high praise from the band parents, fellow students, and the community. After winning eight lower state championships in a row, the band extended that distinction two more years, 1994 and 1995. At the Hawk's Friday night football game halftime shows in 1994 and 1995, the band director and band members of Marching Pride, proudly displayed those trophies. In addition to all those lower state championships, Katy Vogt, Hanahan band director, and Jim Stroman, assistant director, led the Marching Pride to state championships three years in a row, 1986, 1987, and 1988, and again in 1991. (SN.)

Over the years, part of Hanahan's civic activities centered around its civic clubs. It is believed that the first one organized was the Hanahan Civic Club, based on an article from the May 30, 1962, *Hanahan News*. It noted that Francis X. Archibald, president of Hanahan Civic Club, welcomed the formation of Hanahan Exchange Club. At some point, the Otranto Civic Club was formed in the newest community to become a part of Hanahan in 1976 as well as the Hanahan Lions Club. Hanahan administrator Fenton Miller was president of the Hanahan Lions Club at the time this photograph was taken (1992–1993) and is standing to the left of the banner below. Jerry Franks is to the right of the banner along with two other members. (Both, COH.)

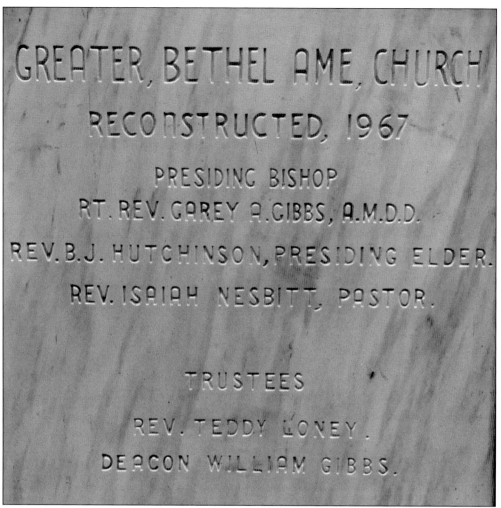

GREATER, BETHEL AME, CHURCH

RECONSTRUCTED, 1967

PRESIDING BISHOP
RT. REV. GAREY A. GIBBS, A.M.D.D.

REV. B.J. HUTCHINSON, PRESIDING ELDER.

REV. ISAIAH NESBITT, PASTOR.

TRUSTEES

REV. TEDDY LONEY.

DEACON WILLIAM GIBBS.

According to a plaque located on Greater Bethel African Methodist Episcopal (AME) Church, the original Bethel AME Church was founded by Rev. M.S. Freeman and a small group of people on April 15, 1954. They built a small frame building at the end of Williams Lane, a dirt road later named for Ertha Lee Williams, who led the effort to get it paved. That road is now a prominent street in the community on which Bowen's Corner Elementary School and a city park, the Hawks Nest, are located. When the Navy access road, now Henry E. Brown Jr. Boulevard, was widened, the church was torn down and relocated at the end of Foster Creek Road and renamed Greater Bethel AME Church. Jestine Campbell and her family attended that church when she was a child. Campbell is a prominent member of her community and a descendant of the slaves who owned the property on which this church is located. (Both, LRF.)

BETHEL A. M. E. CHURCH
FOUNDED BY
REV. M.S. FREEMAN
4 — 15 — 1954

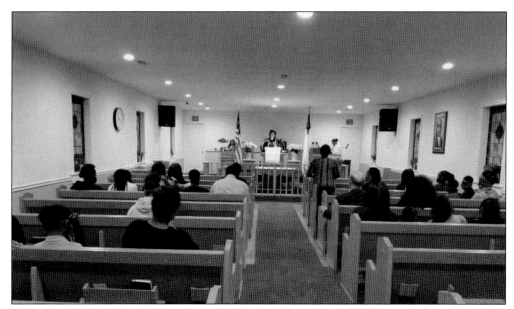

Greater Bethel AME Church was relocated to its current property in 1967. The presiding AME bishop at the time the building was constructed and dedicated was Rt. Rev. Carey A. Gibbs, and the pastor was Isaiah Nesbitt. Deacon Robert Simmons gave the author a tour of the church and cemetery. In honor of a family who once attended the church and now rests beside it, the name McKelvey adorns a building in the new Bowen Waterfront Village community adjacent to the church. The beautiful and inviting sanctuary of this special place of worship is open to all. (Both, LRF.)

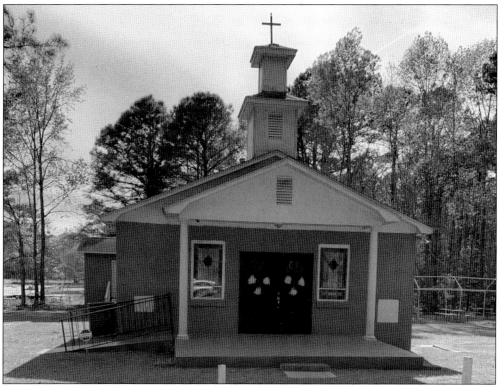

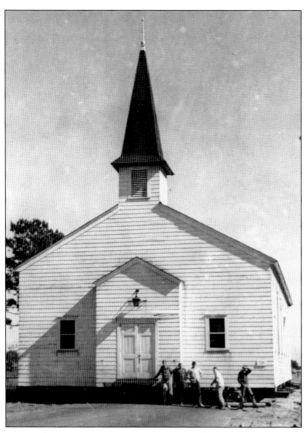

With 33 people present in an open-air service, Aldersgate Methodist Church was chartered on April 28, 1946. At first, Rev. McKay Brabham Jr. was serving as pastor of North Charleston Methodist Church and met weekly with the new church. Three acres of land bordering Remount Road were purchased through contributions. The first building, "the Tabernacle," had a roof and an earthen floor but no walls. With World War II over, the Army had closed down the Army base and prisoner of war camp on Remount Road. In 1947, the church voted to purchase the Port Park Army Chapel with "all its fittings and furnishings." Some members mortgaged their homes to help make the purchase. They moved the building two blocks down Remount Road. Timbers that were used to stabilize the building during the move can be seen under its right side. (Both, SZ, BJW.)

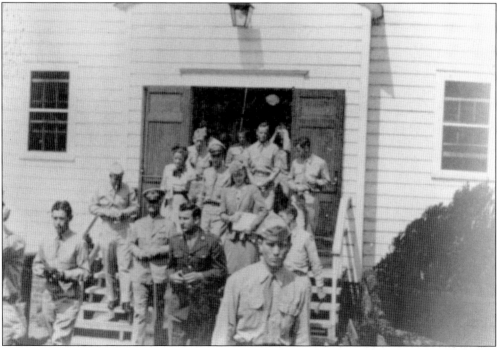

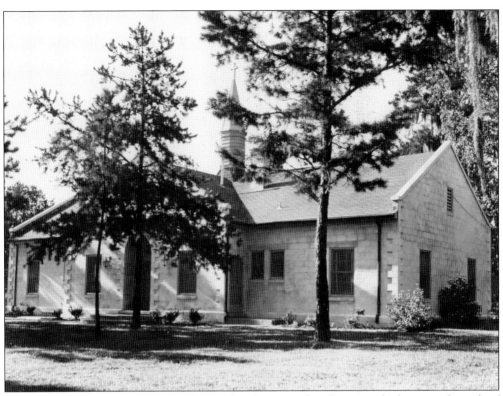

In the summer of 1952, the idea to plant a church in Hanahan began in the hearts and minds of the pastor and members of the now closed Park Circle Presbyterian Church in North Charleston. For several years, a growing congregation was served by student pastors and met at what is now the Fishburne Education Center. The church was formally chartered on October 23, 1955, with 109 members from 45 families. The first building was completed in 1956. That chapel is now known as Memorial Hall. Pictured above is the original church building, and below is the church as it appears today. (Both, YPPC.)

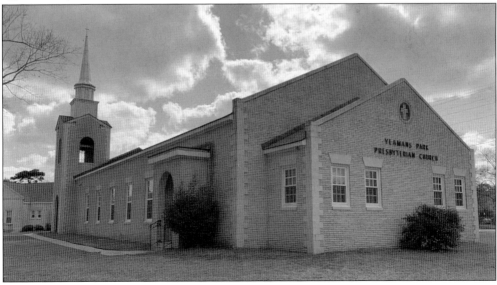

In 1956, the congregation called Rev. Warren Wardlaw as its first installed pastor. With a rapidly growing congregation, Yeamans Park Presbyterian Church added an education building in 1956 and a fellowship hall in 1960. A new sanctuary was built and dedicated in 1968. Pictured at left is the sanctuary of the current church building. Below, a reunion of some of the charter members took place and is commemorated by this photograph made in front of the original church building, which is now known as Memorial Hall. (Both, YPPC.)

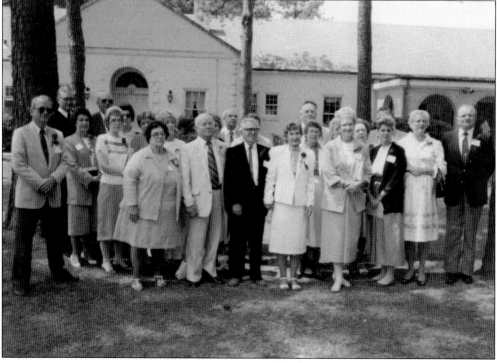

On January 5, 1958, thirty eight people were present for the first service at Highland Park Baptist Mission, a new church being started by a group of people in Hanahan and guided by Charleston Heights Baptist Church, which sent Rev. John Hegler to guide the new church mission. The first deacons were W.J. Kennedy Jr., W.H. Vandiver Jr., Cecil E. Crawford, and R.O. Rodgers. Mildred Dyches was the first Women's Missionary Group president. On July 6, 1958, Highland Park Baptist Church was organized with 73 charter members present. Rev. W.W. Jumper was called as pastor of the newly organized church in July 1959. Pictured are the original sanctuary (above) and the sanctuary as it appears today (right). (Both, BEC.)

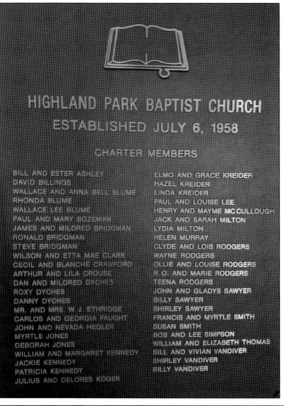

HIGHLAND PARK BAPTIST CHURCH
ESTABLISHED JULY 6, 1958
CHARTER MEMBERS

BILL AND ESTER ASHLEY
DAVID BILLINGS
WALLACE AND ANNA BELL BLUME
RHONDA BLUME
WALLACE LEE BLUME
PAUL AND MARY BOZEMAN
JAMES AND MILDRED BRIDGMAN
RONALD BRIDGMAN
STEVE BRIDGMAN
WILSON AND ETTA MAE CLARK
CECIL AND BLANCHE CRAWFORD
ARTHUR AND LILA CROUSE
DAN AND MILDRED DYCHES
ROXY DYCHES
DANNY DYCHES
MR. AND MRS. W. J. ETHRIDGE
CARLOS AND GEORGIA FAUGHT
JOHN AND NEVADA HEGLER
MYRTLE JONES
DEBORAH JONES
WILLIAM AND MARGARET KENNEDY
JACKIE KENNEDY
PATRICIA KENNEDY
JULIUS AND DELORES KOGER

ELMO AND GRACE KREIDER
HAZEL KREIDER
LINDA KREIDER
PAUL AND LOUISE LEE
HENRY AND MAYME McCULLOUGH
JACK AND SARAH MILTON
LYDIA MILTON
HELEN MURRAY
CLYDE AND LOIS RODGERS
WAYNE RODGERS
OLLIE AND LOUISE RODGERS
R. O. AND MARIE RODGERS
TEENA RODGERS
JOHN AND GLADYS SAWYER
BILLY SAWYER
SHIRLEY SAWYER
FRANCIS AND MYRTLE SMITH
SUSAN SMITH
BOB AND LEE SIMPSON
WILLIAM AND ELIZABETH THOMAS
BILL AND VIVIAN VANDIVER
SHIRLEY VANDIVER
BILLY VANDIVER

According to historical information in a booklet prepared for the 20th anniversary of Highland Park Baptist Church on Sunday July 9, 1978, there were 73 people present for the service in which the church was chartered. The church has since placed a plaque (at left) in the lobby of the main sanctuary with the names of those charter members. There were a number of firsts listed in that booklet, including the first wedding that took place on June 11, 1961, with the coauthor of this book, B. Earl Copeland, and his beautiful bride, Linda Kreider. Rev. W.W. Jumper, pastor, performed the marriage ceremony, pictured below. (Both, BEC.)

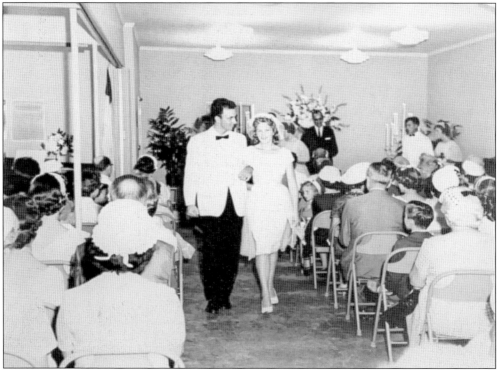

Several of the early churches in Hanahan first met at George R. Fishburne Elementary School, which was the first public building erected in the community in 1950. The South Carolina Evangelical Lutheran Synod prepared and distributed this flyer announcing the first service on Sunday, December 13, 1953, of what was to become Messiah Lutheran Church, which is located on Yeamans Hall Road. (Both, PCC.)

ANNOUNCING

A LUTHERAN CHURCH

FOR

Remount and Hanahan Area

SPONSORED BY

The Evangelical Lutheran Synod of South Carolina

REGULAR WORSHIP SERVICES

WILL BEGIN

Sunday, December 13, 1953

3:30 P. M.

George R. Fishburne School

HIGHLAND PARK

Services Every Sunday

EVERYBODY WELCOME

The Church Follows the People

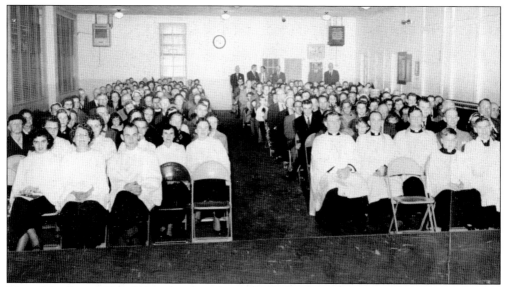

Messiah Lutheran Church founding members included such notable Hanahan citizens as Carl E. Meynardie, Elizabeth "Betty" Richardson, and many others. The church was officially organized in 1955. The first pastor was Rev. Clyde E. Bedenbaugh, pictured below with his wife, Vernell, known affectionately as "Nell," upon their arrival at Messiah Lutheran Church. The church was dedicated and moved into the present sanctuary in 1960. The current pastor is Rev. Craig Versprille. (Both, PCC.)

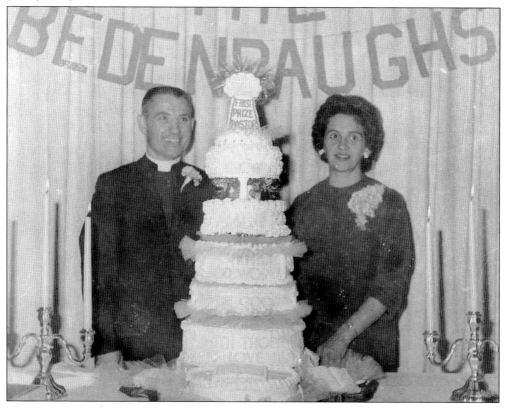

Hanahan Baptist Church was established in the 1960s by a small group led by its founding pastor, Hobson Wolfe, who served for over 20 years until his death in 1985. The church later purchased the house next door as a parsonage. It also purchased a parcel of land in an area of Pickens County known as Pumpkintown that was used as a summer camp named Camp Joy, which was also used as a fall/winter family retreat. It is not clear when that purchase was made, but it was sold shortly after the current pastor, Gamewell Brown, pictured at right, became pastor over 20 years ago. The steeple and a two-story addition were added in the early 1990s. (Both, GLB.)

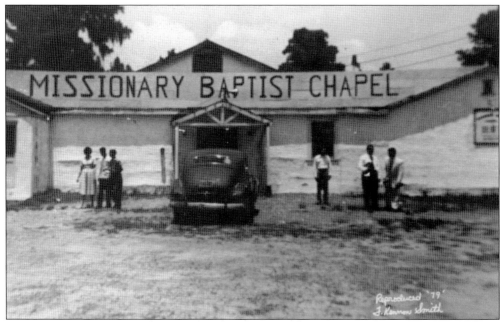

It is unclear just when the original church was started, but information received from David Wilson, who attended as a youngster from 1980 until the mid-1990s, stated that he remembered hearing that Missionary Baptist Chapel, the forerunner of Hanahan Baptist Church, was located on Yeamans Hall Road close to the old Piggly Wiggly supermarket across from the current Hanahan Municipal Complex. Rev. Hobson Wolfe, pictured below with his wife, Phyllis, was the pastor when the Missionary Baptist Chapel became Hanahan Baptist Church in the early 1960s. This picture of the original building hangs in the back of the sanctuary of Hanahan Baptist Church. Judging from the automobile in the photograph, this was taken some time in the late 1940s or early 1950s. (Both, GLB.)

The origin of Christ Sanctified Holy Church on Belvedere Drive was in Chincoteague Island, Virginia. It was founded February 14, 1892. The families who started the Hanahan church migrated from the Virginia coast to the Charleston area. Rev. Ray Smith was a businessman, land developer, and first pastor of the church. In the 1950s, he and his business partner, T.A. Bonner, bought the large tract of land where they built Belvedere Estates. Reverend Smith bequeathed the land on which he built the church. Reverend Smith and his wife, Eula (Jones) Smith, are pictured at right and with members below at a church reunion in 1974. (Both, BC.)

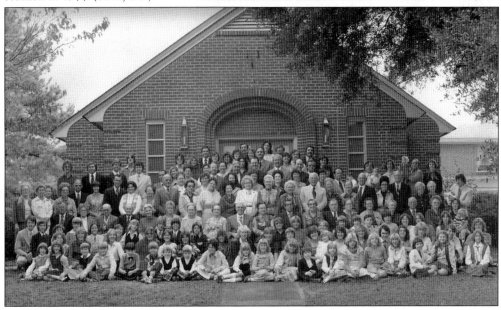

Divine Redeemer Catholic Church was founded in June 1956. Its first services were held in the papermill's athletic hall at the corner of Remount Road and North Rhett Avenue where Sunday Masses continued to be held until February 1958. Groundbreaking for the present sanctuary, which is located at the corner of Murray Avenue and Fort Drive, was held on July 14, 1957. The first Mass in the new church building was held February 23, 1958, and the church building was dedicated on September 14 of that year. (DRC.)

On June 15, 1956, Fr. Jerome Powers was appointed pastor of Divine Redeemer Catholic Church. In October 1957, the church purchased a residence on Recess Road, a block from the new church then being built, to be used as a rectory. A convent was then built in 1964. (DRC.)

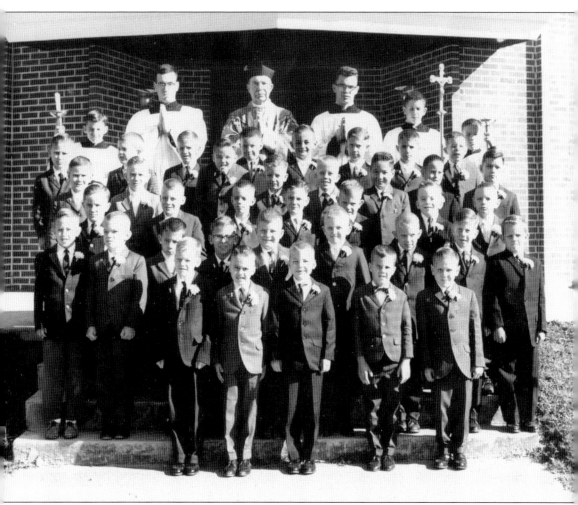

In 1960, Divine Redeemer School was established adjacent to the church sanctuary where it continues to serve children in the community to present day. In 1989, a parish hall was built and four more classrooms were added to the school. Later that same year, the church sanctuary was destroyed by Hurricane Hugo. The newly renovated church building was dedicated on April 14, 1991. Pictured is the first priest of the church, Jerome Powers (top row, center), with a group of young members. (DRC.)

The old Port Park Nazarene Church, later renamed Hanahan Church of the Nazarene, was founded on Robinson Street in the 1950s. According to Alice (Adams) Dukes, her family attended that church in the 1950s when her father was stationed at Charleston Air Force Base and Rev. J.D. Powers was the pastor. Her father was transferred to Virginia but returned to Charleston in the mid-1960s. When they rejoined the church, Rev. Raymond Deshon was pastor. Reverend Deshon encouraged her father to become a minister, first serving as youth pastor of the Hanahan church. Later, the church was moved to Dorchester Road, and the building was sold. At one point, the church building was structured with the sanctuary above basement rooms. Later, the basement was removed, lowering the building level. (Both, BEC.)

In 1957, a new Episcopal mission was established on Yeamans Hall Road. It was sponsored by St. Michael's Episcopal Church in downtown Charleston. The first services were held at Fishburne Elementary School. Rev. St. Julian Lachicotte was the first vicar. Under his leadership and with the guidance of Eleanor Haskins, a day school was started in the garage of the new vicarage that was purchased in 1961. Later, an educational building was constructed. A plaque by the front door showed that it was dedicated to Eleanor Haskins. In 1971, the Church of the Holy Spirit merged with the Church of the Good Shepherd to form St. Thomas Episcopal Church. The school continued as Holy Spirit Day School until the property was sold in 1991. (Both, BEC.)

The property that was once Holy Spirit Episcopal Church, which continued to be used as a day school until it was sold, was purchased by and became First Church of the Nazarene of Hanahan. Its pastor for over two decades has been Gary Rupert. (BEC.)

Rev. Robert Tilton is the founding pastor of Shield of Faith Community Church, which is nondenominational, and he has continued as pastor ever since. The church constructed and dedicated the main sanctuary building in 1987. Since then the church has added a second building that houses a social hall, Sunday school rooms, and offices. The church is located at the end of Foster Creek Road. (RRT.)

According to a 1988 newspaper article in the *Charleston Evening Post*, Rev. Robert Tilton felt a strong call to the ministry. As a 41-year-old Air Force veteran working as a civilian employee at Charleston Air Force Base, he obeyed the call, and a year later in 1975, he and a small group of people started the church in his home. Within a year of the first service, 70 people formed Shield of Faith Ministry. The church continued to meet in Pastor Robert and Susan Tilton's home in Hanahan for over a decade, until the sanctuary was built. (Both, RRT.)

Restoration Community Church was launched in 2013 as God had placed a burden for Hanahan and vision on the hearts of a few local families. Restoration was birthed to "make and equip disciples of Jesus who love, lead and serve" in Hanahan. By God's grace, 10 years later under the leadership of Pastor Adam Spurlock, Restoration Community Church continues to serve the area by showing the love of Jesus through its backpack ministry, "yard give" (the name used for the church's backyard ministry), and simply loving on neighbors. (Both, AS.)

Five

PRE-INCORPORATED HANAHAN AND EARLY BUSINESSES

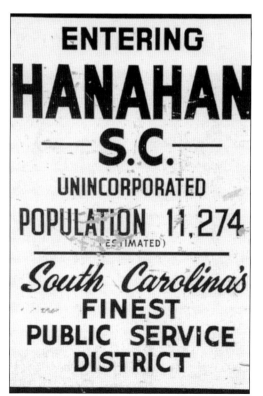

This is the actual sign that stood at the entrance to Hanahan on Yeamans Hall Road at the intersection with Remount Road during the time Hanahan was a public service district. Since incorporation as a city in 1973, it has held an honored place inside Blackwell Building Supply, above the entrance. Leroy Blackwell, founder and owner of Blackwell Hardware and Building Supply, requested it from the City of Hanahan in order to preserve it and to display for all who entered his business. (CC.)

The Blackwell family has always been known for their service, but first and foremost, their service to country. Then, for several generations, family members have served their community in business. Note this certificate received from President Truman. It notes Leroy Blackwell's dedicated service in the Merchant Marines. It also calls attention to his leadership qualities. That fits this homegrown patriot exactly. (Both, CC.)

LEROY BLACKWELL

To you who answered the call of your country and served in its Merchant Marine to bring about the total defeat of the enemy, I extend the heartfelt thanks of the Nation. You undertook a most severe task—one which called for courage and fortitude. Because you demonstrated the resourcefulness and calm judgment necessary to carry out that task, we now look to you for leadership and example in further serving our country in peace.

Harry Truman

THE WHITE HOUSE

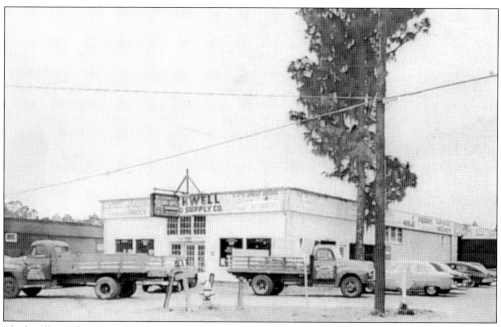

Blackwell Hardware and Building Supply Company was the first-known business on Yeamans Hall Road in what would later become the city of Hanahan. The origins of the store are said to date back to the late 1940s when the Blackwell brothers, Leroy and John, returned home following World War II. The Blackwell family purchased the old Army ammunitions building at the corner of Yeamans Hall Road and Carolyn Street where it is still located today. This early-1950s photograph is the earliest image of the building to be found. Pictured below is Leroy Blackwell, owner. (Both, CC, BBB.)

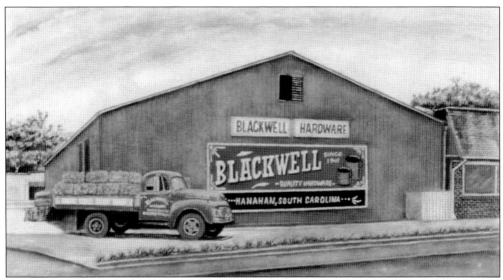

This painting of Blackwell Hardware was done by Hanahan resident and artist Donald Roberts. The scene of the 1950s-era warehouse was taken from a photograph. This family is known for its business ethics, and this store is a historic landmark in the city of Hanahan. Blackwell Hardware, also known as Blackwell Hardware and Building Supply Company, was started by the Blackwell family in the late 1940s. Leroy Blackwell's brother John Edward Blackwell operated his insurance business from part of the same building for decades. It served the people of Hanahan and surrounding areas for several generations. Today, Leroy's grandson Chad Chinners operates Blackwell Hardware. (DR.)

The building in this painting done by Hanahan artist Donald Roberts stood on the corner of Yeamans Hall Road and Griffin Street. It was originally built as a military warehouse by the Army in the 1930s and was later sold to Kenny Hammond. It was used as a freight terminal for Hennis Freight Trucking Company. After the truck terminal closed down, the property was rented and used as an antique and auction business by Ed Roumillat. A short time later, Roumillat bought the property and continued to use it as an antique and auction business until he moved his business to Savannah Highway. He then rented it to his friend Robert Keen in 1993 and encouraged him to get his auctioneer's license. Keen used it as an auction house for several years. Roumillat later sold the property to Calhoun Investments in 2005. It was then torn down to make way for the present shops at that location. (DR.)

In the early 1950s, Carl E. Meynardie Sr. and a few other community leaders set about to form a community newspaper. The result was the *Hanahan News*, which Meynardie first published in his garage at 1037 Lepley Road. He was publisher and editor for over 50 years. He is considered by many to be the single most influential person responsible for the sense of community that Hanahan has always enjoyed and which still defines the city today. His wife, Grace, worked side by side with Carl over those many years. Pictured at right is Carl inspecting one of the earliest editions hot off the press in 1955. Below, state representative Henry Brown (left) presented Carl with South Carolina's highest civilian award, Order of the Palmetto, on behalf of Gov. Carroll Campbell. The ceremony took place in front of the hometown crowd at a Friday night football game during halftime while Carl's wife, Grace, looked on. (Both, CMJR.)

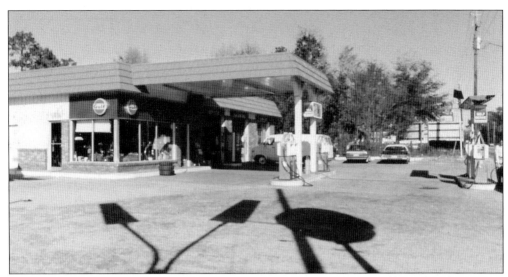

The Berkeley Gulf Station that once stood on the corner of Yeamans Hall Road and Remount Road was run by Vernon and Edith Black for 20 years, from 1967 to 1987, shortly after which time the property owners sold it. The Blacks have always been proud Hanahan residents. Sometime in the late 1960s, the above photograph, looking eastward down Remount Road prior to it being widened to four lanes in 1967, captured the business. Over the 20 years that the Blacks owned the business, Edith and Vernon received many awards for excellence, including paid trips, from Gulf Corporation. (Both, VEB.)

The first Farley's Barbershop was in the end of an old Army barracks across from Hanahan City Hall where First Citizens Bank is located now. Floyd and Eula Farley had six boys, but only Floyd and three of his sons were barbers, Milton, Alfred, and Phillip. The family lived in one end of the building, and Floyd had a small shop in the other end, which he started around 1955. Then the shop was moved to the Yeamans Hall Plaza on Easter weekend 1962; it remained there until Phillip, the last Farley to run it, retired. (PF.)

Farley's Barbershop was the nerve center of political life in Hanahan. Almost every man in Hanahan got their hair cut at Farley's, but especially those who wanted to keep up with what was happening. Two of the Farleys, Milton and Phillip, went on to become both Hanahan city councilmen and Berkeley County councilmen. (PF.)

Six

Post-Incorporated Hanahan and City Government

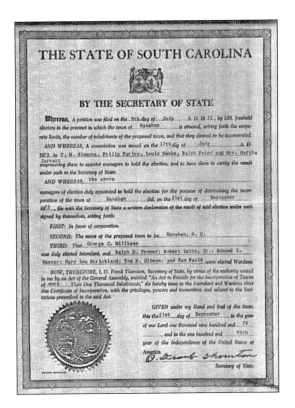

The certificate of incorporation for Hanahan shows an election commission composed of T.M. Simmons, Phillip Farley, Louis Weeks, Ralph Foler, and Martha Jarrett. In addition, the names of the candidates for mayor and city council were included in the event the referendum passed. The citizens chose to incorporate and elected George Williams as mayor and Ralph Proper, Robert Lebby Jr., Edmund Hester, Mary Lou Strickland, Tom Gibson, and Sam Faulk as members of council. (KWW.)

Pictured is Mayor George Williams shortly after taking office as the first mayor of Hanahan in September 1973. Below, in 1977, Mayor Williams was sworn in after being elected to a second term. Hanahan magistrate Leo Zolnierowicz presided while the mayor's wife, Alene, held the Bible and council member Marion Dudley looked on. (Both, KWW.)

Above, Mayor George Williams (left) shakes hands with First District congressman Tommy Hartnett (center) while Francis X. Archibald (right) looks on at the Exchange Park. Below, Mayor Williams and others enjoyed a cookout at Exchange Park on Highland Park Avenue. (Both, KWW.)

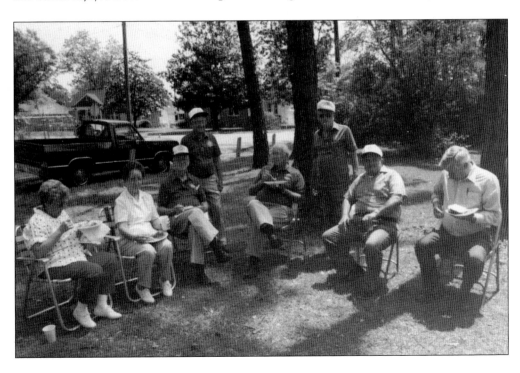

The HANAHAN News

U.S. POSTAGE
PAID
Charleston, S.C.
PERMIT NO. 1361

VOLUME XVII, NUMBER 37 "The Paper With The Community Spirit" THURSDAY, SEPTEMBER 25, 1975

Council members look on as newly elected Mayor Earl Copeland is sworn into office by City Judge Lester F. Bevil. Left to right are John R. Reeder, Marion T. Dudley, Dorothy C. Cease, Copeland, Bevil, Ralph D. Proper, Mary Lou Strickland, and Edmund L. Hester.

You Are Needed!

Schools Launch New Volunteer Program

by B.J. Hale

If you have ever wanted to help improve the Charleston County Public School system and didn't know how to go about doing it, your time has come. It doesn't matter if you are a conscientious student, a busy housewife, or a

According to Ronald A. McWhirt, assistant superintendent of schools in Charleston County, a new county-wide "School Volunteer Program (SVP)" was launched this week. SVP will use three types of

District coordinator; Mrs. Gerry Pfaehler, St. Andrews-St. Paul School District coordinator; Mrs. Gladys Richbourg, Johns Island School District coordinator; Mrs. Oakie Colson, James Island School District coordinator, and

Mayor, Aldermen Take Oath of Office

Hanahan's new mayor and six aldermen, including three incumbents, were administered the oath of office by City Judge Lester F. Bevil Monday night, while family members, friends, and a few interested citizens looked on.

Mayor Earl Copeland was the first to be sworn in, followed by the aldermen, Mary Lou Strickland, Marion T. Dudley, Dorothy C. Cease, Ralph D. Proper, John R. Reeder and Edmund L. Hester.

The new city government moved quickly to approve unanimously several actions. However, a motion made by Councilwoman Dorothy C. Cease to change the meeting night from Monday to Tuesday or Wednesday failed to get a second.

Mayhor Copeland told council that the issue would have to be discussed further. "Monday

night is the one night that I absolutely cannot make," he said, pointing out that his job required him to work on that night.

"We must change the meeting night if I am to do the job the people elected me to do," the mayor said.

In other actions, Councilman Edmund L. Hester was elected mayor pro tempore, a position he held in the previous administration, and council voted to maintain all standing committees in their present form until members could get together to work out permanent assignments.

Council also voted to continue current salaries of $100 monthly for each of the six aldermen and $125 for the mayor, to retain City Manager Hugh Smith, Ann S. Holst, Clerk-treasurer, and all department heads for the present time.

During the meeting Councilwoman Cease asked for a status report on the engineering drainage study which is supposed to be in progress. The city manager said that $35,000 had been allocated in the current city budget for the study, and that $3,000 had been set aside for an

Arts, Crafts
Fair To Feature
Christmas Items

All sorts of Christmas presents for the entire family will be on

On September 25, 1975, the local *Hanahan News* reported on the swearing in of the second person to serve as mayor of the city of Hanahan, B. Earl Copeland, officiated by Judge Lester Bevel. Also sworn in were the newly elected city council members Jack Reeder, Marion Dudley, Dorothy Cease, Ralph Proper, Mary Lou Strickland, and Edmund Hester. The first meeting of the new council followed the swearing in ceremony. Mayor B. Earl Copeland, pictured at left, was elected as a write-in candidate. (Above, BEC; left, COH.)

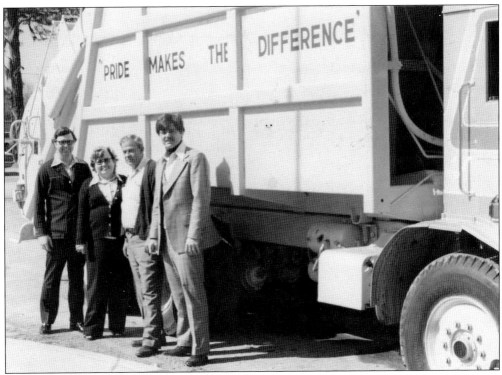

In 1976, the first new garbage truck was ordered by the City of Hanahan and was received in early 1977. There to greet the new arrival are, from left to right, Mayor Earl Copeland, council members Mary Lou Strickland and Jack Reeder, and city administrator Ron McLemore. In 1977, the city received its first new fire truck. (COH.)

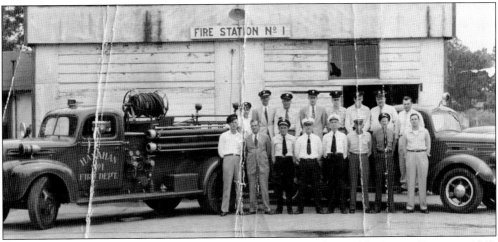

The Highland Park Fire and Water District was changed to Hanahan Public Service District in 1947, allowing the community to provide sanitary and stormwater sewer systems, parks and recreation, refuse collection, fire protection, and potable water service. The photograph here, which is displayed in Fire Station No. 1 on Campbell Street adjacent to city hall, is believed to have been taken in the late 1940s or early 1950s. It was the first firefighting unit in Hanahan, manned by three to five full-time fireman and volunteers. Pictured in the back row, second from left was Chief Henry Morgan with the volunteer brigade. (COH.)

Hanahan City Hall and the police/fire departments building stood on the corner of Yeamans Hall Road and Campbell Street. City hall was very small and abutted the city gymnasium. There was a parking lot between it and the police/fire building. Both buildings were torn down to make way for the new Hanahan Municipal Complex in 2003. (Both, COH.)

Marion Dudley was first elected to Hanahan City Council in 1975. He served two terms before being elected as Hanahan's third mayor in 1981. Dudley served two terms, from 1981 through 1989. In the photograph above , Mayor Dudley holds a shovel, flanked by, from left to right, councilman Charlie Cox, councilman Ed Sessions, city administrator Mike Martin, and councilman Donald Austell. Pictured below is the swearing in ceremony following the 1977 election. From left to right are councilman Marion Dudley (partially hidden), councilman Tony Martin, councilman Larry Carson, councilman Wilson Thrower, and councilman Ron Hoar, and presiding is Hanahan city judge Lester Bevil. (Both, COH.)

Among the fun things that the mayor and city council have had the opportunity to do is to interact with citizens at gatherings sponsored by the city recreation department, such as sporting events and holiday celebrations, like Halloween costume contests. Pictured are, from left to right, city council members James Cade, Betty Ricketts, and Milton Farley with three unidentified contestants, and Mayor Marion Dudley. In 2022, the current city council continues the tradition as evidenced by Snow White and the dwarfs below. (Above, COH; below, CHR.)

In 1989, Larry Cobb was elected as the fourth mayor of Hanahan and served three terms. Mayor Cobb was sworn in by state representative Henry Brown, who officiated while Mayor Cobb's wife, Maureen, held the Bible. Councilman Milton Farley is pictured behind Maureen Cobb. Below, in 1993, Mayor Cobb is pictured with, from left to right, city council members Ron Mosely, Gerald Dodd, and Milton Farley, Cobb, and city council members Sharon Lee, Ed Sessions, and Charles Cox. It was during Mayor Cobb's time as mayor that the old city hall, police station, and fire station were demolished and the new Hanahan Municipal Complex was built. (Both, COH.)

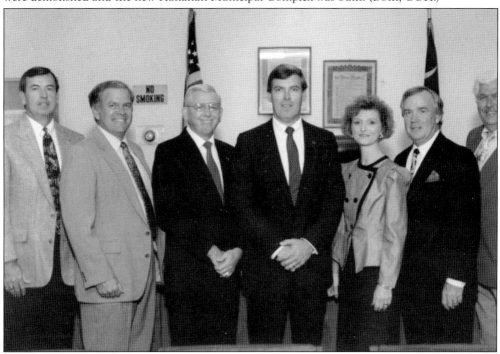

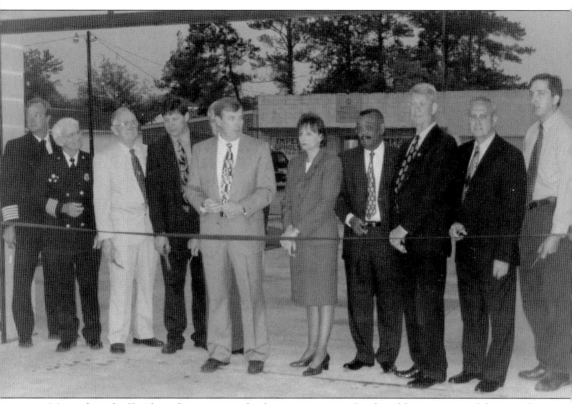

Many elected officials and community leaders were present for the ribbon cutting of the new fire station. Pictured in this 1998 photograph are, from left to right, assistant fire chief Jerry Barham, fire chief Billy Hendrix, councilman Jack Milton, councilman Jeff Chandler, unidentified (partially hidden behind the mayor), Mayor Larry Cobb, councilwoman Minnie Newman, possibly James White (building contractor), councilman H.L. Dukes, councilman Ralph Watson, and Arnie McClure (building architect). (COH.)

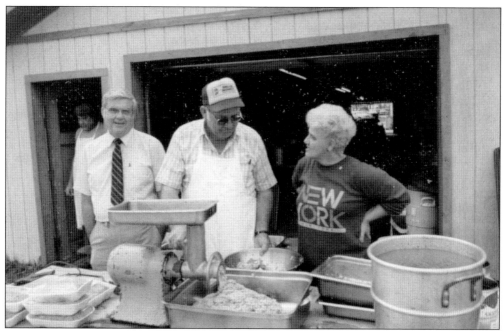

While Linda Brown was Hanahan city recreation director, the department sponsored numerous events that served food, including senior citizen gatherings and others. Barbecue is being prepared for a couple of these events. City administrator Mike Martin was hands-on, as seen in both of these photographs. Above, Martin (center) is pictured with recreation director Linda Brown (right), an unidentified cook in the doorway, and another unidentified man. Below, Martin is pictured in his apron with several unidentified people. In the background, a good view of the original Hanahan Police Department and part of the Hanahan Fire Department and city hall, which were later demolished to make way for the new municipal complex, can be seen. (Both, COH.)

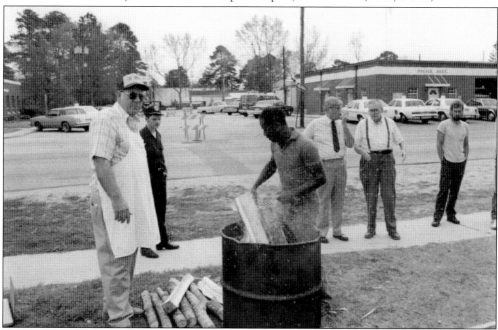

Anne Farley began her public service immediately out of high school in 1962 when she joined the Hanahan Public Service District staff. During her time, she served in the dual role as clerk of council and city treasurer for many years. In addition, she served as interim city administrator numerous times. However, city council appointed her as city administrator in 1991, a position in which she served until her retirement in 1992. Farley can be seen with the four mayors under whose administrations she served, from left to right, starting with Mayor George Williams in 1973 and continuing through the terms of Mayors Earl Copeland, Marion Dudley, and Larry Cobb. Below, from left to right, Debbie Lewis, Betty (Martin) Richardson, and Anne Farley were three amazing administrative employees who, between them, served 90 years. (Above, ASF; below, DL.)

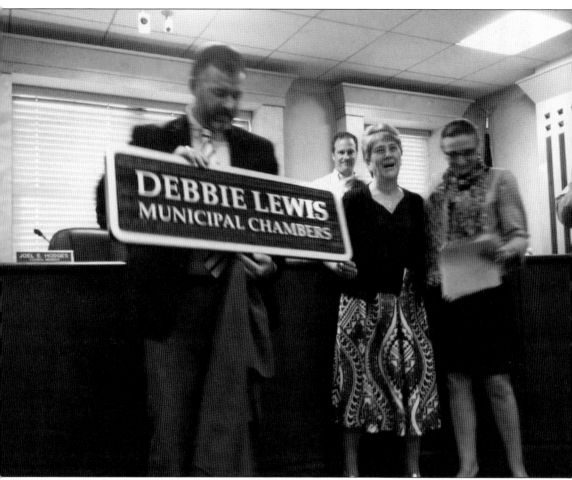

Upon her retirement, Debbie Lewis was honored by the Hanahan mayor and city council who named the council chambers for her. She is shown here with city administrator Johnny Cribb (left), Minnie Newman (right), and councilman Michael Sally (background). During 40 years of service (1975–2015), Lewis was secretary to all city administrators and clerk of council. She also worked in the departments of city court, police, planning, zoning, elections, and building and codes. Wherever assigned, she readily served with integrity and professionalism. (DL.)

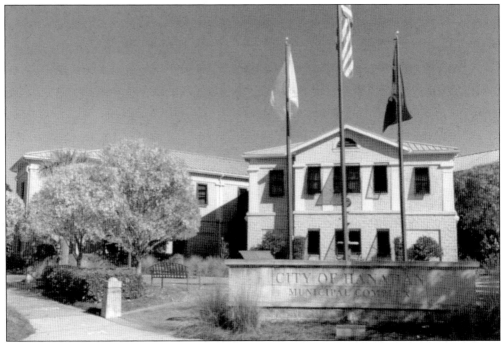

Built in 2001 while Larry Cobb was mayor, the new Hanahan Municipal Complex houses administrative staff offices; council chambers, which also doubles as municipal court chambers; and the police department. It is located on the corner of Yeamans Hall Road and Campbell Street where the old city hall, police department, and fire department buildings were before being demolished. The new fire station was built earlier beside the city complex building. Pictured below is the current serving mayor and council. From left to right are councilmen Kevin Hedgepath, Michael Sally, and Adam Spurlock; Mayor Christie Rainwater; and councilmen Jeff Chandler, Mike Dyson, and Ken Boggs. (Above, BEC; below, COH.)

Hanahan built the city gymnasium, senior center, and amphitheater adjacent to the recreational complex on Railroad Avenue during Mayor Minnie Newman's time in office. This beautiful amphitheater, built in 2013, is one of the most popular Hanahan facilities. Popular events include the annual Hanahan Red, White, and Blue Festival, which draws hundreds of people from throughout the Lowcountry; concerts; movies in the park; and other community events. (DR.)

Mayor Minnie Newman was elected in 2002 as the fifth mayor of Hanahan and served four terms (2002–2018). Prior to that election, she served as a council member for seven years. Mayor Newman stated, "It was a great honor and privilege to serve the great community of Hanahan as a council woman and the mayor." During her administration, Hanahan had accomplished many things that improved the quality life for citizens, including, with the help of Congressman Henry Brown, the City of Hanahan acquiring its very own zip code for the first time in history. (Both, DR.)

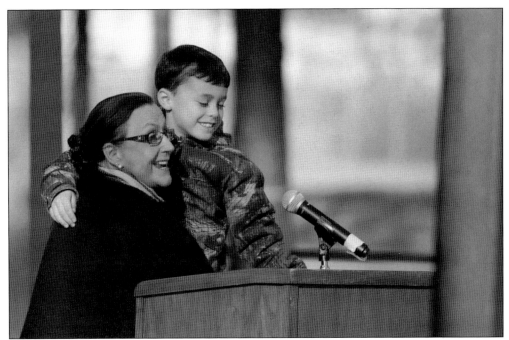

Additional focus was placed on the following areas: infrastructure, the new amphitheater, new residents, schools, recreation, the senior center, water and sewage to Bowen Corner, and more. Mayor Newman, pictured with Eli Bullington, had a beautiful focus on having the children, the future of the city, participate. The things that the mayor and council were able to accomplish was due to listening to the needs of community members and acting on their needs whether a person was 5 years old or 95 years old. They listened, and they acted as a team. (DR.)

Former mayor Minnie Newman said, "For me it was about governing for the people, by the people, always listening to the needs of our citizens, young and old, and being accountable to our community. It was all about servant leadership, serving Hanahan with my heart." (MN.)

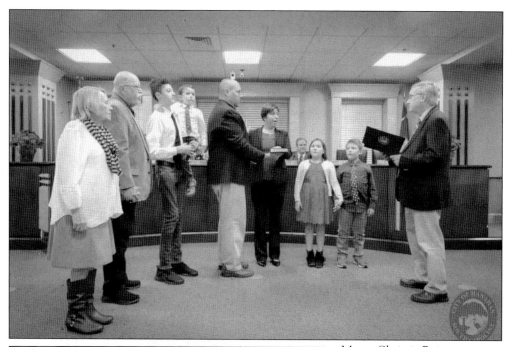

Mayor Christie Rainwater was first elected as a city council member in March 2017 during a special election. She then ran for mayor during the general election in November 2018 and won. After running unopposed, she was sworn in for a second term as mayor where she continues to serve the city. Rainwater also serves on several boards across the Lowcountry, including as vice chairman of the Charleston Area Transportation Study committee (CHATS), Executive Council of Governments Board, Council of Government Board of Directors, CARTA Board, and several others. Rainwater's most valued roles are wife and mother to her four children. (CHR.)

Mayor Rainwater's vision has been to help each person in her community to discover their God-given talents and passions and use those to be difference makers. She believes that together much more can be accomplished. Each year, Mayor Rainwater does a "Difference Maker" art contest at all four Hanahan schools. The pieces of art that are chosen then hang in the mayor's office in city hall for one year, allowing the children's beautiful art to speak to each visitor to her office. (CHR.)

A road to connect Hanahan proper to the Eagle Landing and Otranto subdivisions had been initially proposed when Otranto was annexed in 1976. The project was earmarked by Rep. Henry E. Brown Jr. in the 1990s while he served as chairman of the South Carolina House Ways and Means Committee and later when he was in Congress. Thanks to the persistence of all former mayors and council members, former Hanahan city administrators, current Berkeley County supervisor Johnny Cribb, and current city council and Mayor Christie Rainwater, the city is now interconnected. (COH.)

From the lunch buddies mentoring program to doing roadside trash clean up and everything in between, city council has always worked alongside staff in the community. One example of walking in the shoes, or boots, of staff is pictured above through a firefighter training exercise where city council member Michael Sally and Mayor Christie Rainwater suited up and went into a burning building alongside Hanahan firemen. With smoke billowing and temperatures over 800 degrees, they learned firsthand all that is needed to fight a fire, from equipment to training. (Both, CHR.)

The city of Hanahan faced the COVID-19 pandemic along with the rest of the world. The city held some of the lowest statistics in the state due to the hard work of staff and application of common sense. While the city council never imposed any ordinances for masks or vaccines, they used communication and created easy opportunities to do what they could with what they had, including a COVID-19 testing and vaccine site. The City of Hanahan was presented with several awards for saving lives, including the Municipal Association of South Carolina (MASC) Achievement Award for Public Safety, as pictured below. (Both, CHR.)

During the 2010s, the city grew in population approximately 60 percent. There was a need for the expansion of recreational facilities as well as to focus on economic development. In addition to upgrading all current parks, the city expanded the parks to include a boardwalk along the reservoir and two new parks. The Hawks Nest will reach its maximum potential thanks to the collaboration between the City of Hanahan, Berkeley County Schools, Berkeley County, and the federal government. The other park is being developed at Steward Street and will include a boardwalk, kayak launch, playground, and more. One other park was added as well for furry family members. Hanahan's dog park on Murray Drive opened in 2022. A different kind of park also was started. Yeamans Hall Canteen was a food truck park established in 2020 with the purpose of bringing to life the downtown area of Hanahan. Coupled with an investment in new landscape, sidewalks, and lighting, the downtown of Hanahan has come alive. (Both, COH.)

Seven

HANAHAN RECREATION

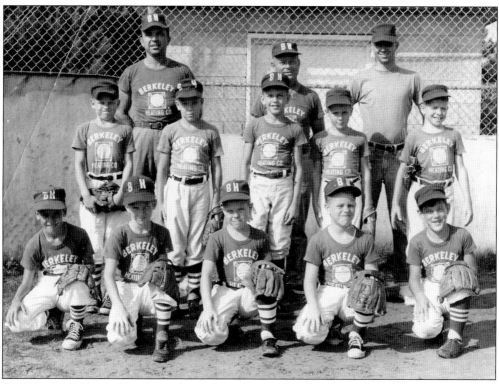

Prior to the 1973 incorporation of Hanahan as a city, most of the athletic programs in the area were run as a part of Cooper River Parks and Playgrounds. This photograph shows the 1963 Berkeley Heating and Air–sponsored small fry team coached by Bob Simpson, Lonnie Wall, and Earl Copeland. The small fry league played its games on Crane Field in WestVaCo Park. (BEC.)

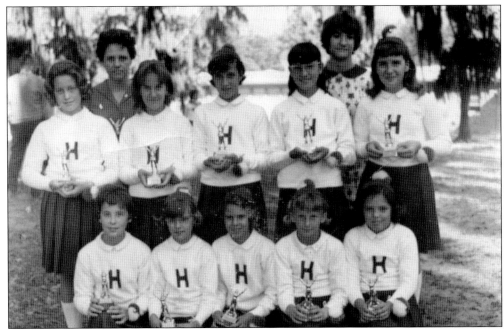

In 1966, prior to the incorporation of Hanahan, the parks and recreation was formed as part of the Hanahan Public Service District. The team pictured here, Hanahan Rams, was coached by Mary Riggs and her daughter Jennifer Riggs. The team members were holding trophies presented at the end of the season competition for the best squad. (CSG.)

Located on the corner of Remount Road and North Rhett Avenue, the complex was built by West Virginia Pulp and Paper Company in the 1940s for use by their employees and families. It was later opened to the public with three ball fields, a clubhouse, and a swimming pool. The photograph was most likely from the 1950s. In the early 1980s, the City of Hanahan contracted with WestVaCo for the use of the pool. According to Linda Brown, Hanahan recreation director at the time, she ran a summer swimming program with approximately 300 children participating every summer. (SMS.)

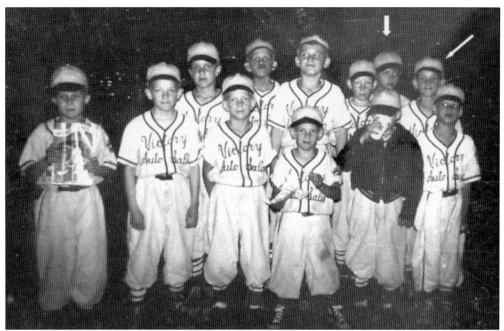

Prior to the incorporation of Hanahan as a city with its own recreation department, boys of Hanahan and the area known as Charleston Heights (now the city of North Charleston) played in leagues that were part of Dixie Youth Baseball Inc., a southern version of Little League baseball. West Virginia Pulp and Paper Company, at the behest of the Cooper River Parks and Playgrounds Commission, built three baseball fields on the corner of Remount Road and North Rhett Avenue. They were Crane Field, adjacent to the Paper Mill Club and swimming pool; Burnes Field, shown in the photograph below; and Cook Field, nearest the street intersection. Teams like the one pictured were not part of the organized leagues but had sponsors and would compete against any team that would play them. (Above, CMJR; below, JT.)

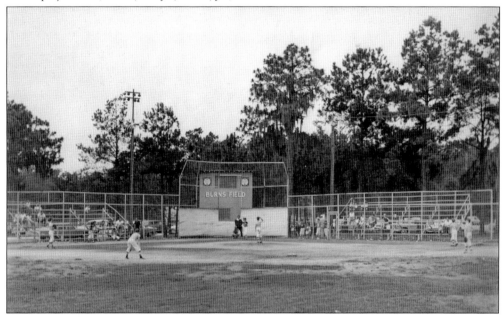

The predominant sports in the early years of organized youth sports in Hanahan were baseball and football. Although Hanahan High School included boys' and girls' basketball, the recreational sports did not have indoor facilities. Youth baseball was played at WestVaCo Park, and youth football was played at Spell Field, across from Hanahan Middle School. Pictured are the Bantam League All-Stars, coached by Woody Horne, Al Chubb, and Bobby Turner. (BT.)

One of Hanahan's most dedicated volunteers was Bobby Turner, who coached for many years. Turner was later hired by the Hanahan Recreation Department as one of the groundskeepers. Until his death at an early age, Turner could be seen mowing the grass of the ball fields or other Hanahan facilities, doing what he loved. He found such joy just being around ball fields or coaching. Pictured in this 1972 photograph is one of the many teams that Turner, back center, coached over the years. (JT.)

Without the volunteers who stepped forward year after year to coach youth sports, the programs could not have operated. Usually, it was parents of children who invested their time and effort in order to give all children the opportunity to participate. One of literally thousands of parents to do so over the years was Tony Martin (third row, right). Pictured with Martin and their small fry team are coach Charles (?) Cox (third row, left) and team sponsor Ralph Stanley (third row, center). In addition to serving on Hanahan City Council and as Hanahan court bailiff, Martin served many years coaching football, baseball, and boxing. He was a vital part of Hanahan's community life, long before it was incorporated as a city in 1973. (PM.)

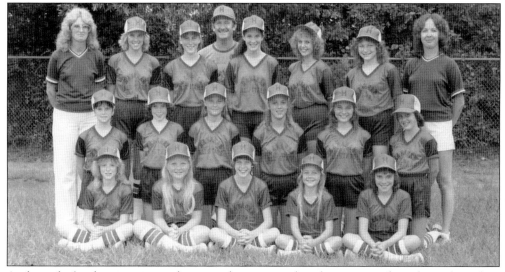

At the end of each season in youth sports, the team coaches chose outstanding players from their team to be on the all-star team for that league. The coach that won the championship is chosen to coach the all-stars. He or she gets to choose his assistant coach, usually, but not necessarily, from his/ her own team. Depending on the league rules, sometimes the team would go on to play teams from other area programs. This 1983 girls' softball all-stars team, coached by Betty Norman, left, Joe Bartee (center), and an unidentified adult (right), is representative of many teams over the years. (KCO.)

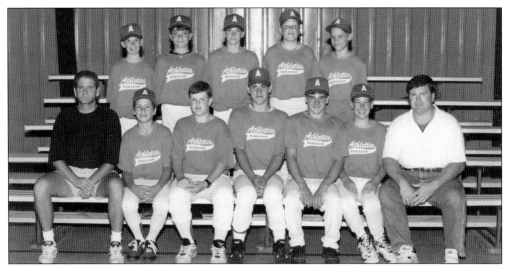

At times when the Hanahan Recreation Department did not have enough players signed up in a particular sport and age group to field over two teams, the director would reach out to other communities close by to find a league in which Hanahan players could participate. The 1992–1993 Hanahan Athletics team, ages 12 and 13 and coached by Sam Huggins (seated, left) and Rick Stells (seated, right), was such a team. (MMC.)

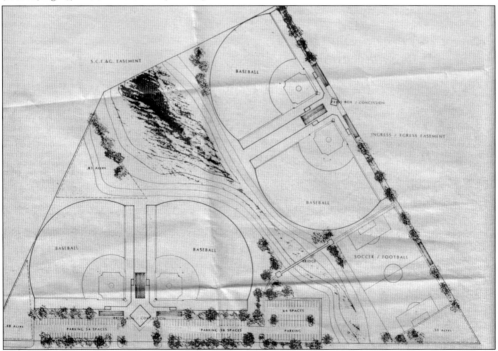

During the administration of Mayor Larry Cobb, the Railroad Avenue Hanahan Recreational Complex was constructed using a federal community recreation grant. The City of Hanahan engaged Charleston architect Ray Huff to design the new recreation complex. The final design included four baseball/softball fields, one football/soccer field, multiple small buildings for concession stands and scorekeeper's booths, and ample parking lots. This design rendering by the architect was approved by city council. (COH.)

In the 1980s, Hanahan's director of recreation, Linda Brown, tried to get participation of all ages in some sort of recreational activity. There was an existing group of senior citizens who met informally but were not actively opening its membership to all seniors. Brown started a group that would get together every two weeks to socialize and share a meal that was donated. That was the forerunner of the Hanahan Senior Citizens Center. Below, at the dedication of the new sports complex, using a flatbed trailer as a platform, Mayor Larry Cobb congratulates Linda Brown on a job well done as other invited participants look on. (Both, COH.)

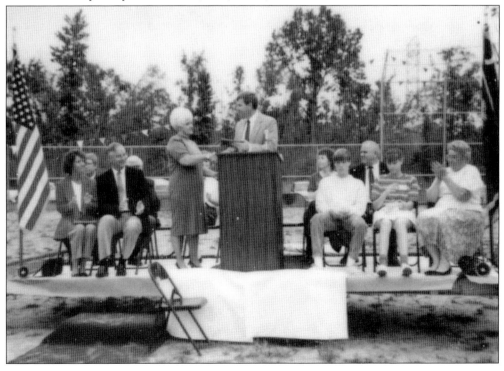

When it came to building the many fields that make up Hanahan's recreation complex, much of the work was done by volunteers. Where there were not volunteer skills available to do certain jobs, the city hired contractors. In addition to local volunteers who provided much of the manpower in constructing many of the sports complexes in Hanahan over the years, even including some at the school facilities, many times different organizations would provide volunteers who received credit by those organizations for community service. Here, a local group of Army Reserve soldiers, enlisted by city administrator Mike Martin, are providing the manpower to install ball field bleachers. Kudos to the military. (Both, COH.)

Hanahan's recreation department included all ages, both men and women, girls and boys, in a variety of sports programs. For many, it offered the only opportunity to participate in organized sports. Pictured above is the Young at Heart men's softball team in the 1980s. There were not enough in the 65-to-80-year-old age group to form a league in Hanahan, so they played other areas that could field a team. The photograph below shows participants of a Hanahan youth soccer clinic, conducted by Tom Mulroy, to give boys and girls the basics in playing the game. (Both, COH.)

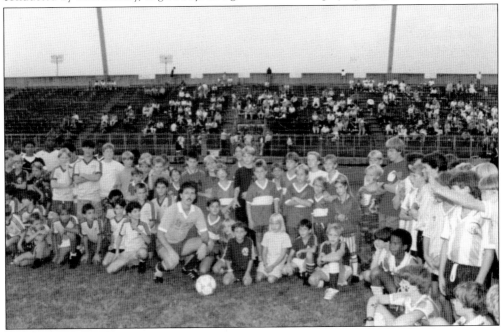

Throughout the years, citizens voluntarily gave of their time and talents to run the recreational programs. Without those volunteers, the programs would not have been possible. They received the grateful support of members of the community as well as Hanahan officials. Councilman Milton Farley, left, shakes hands with Steve Jarrell (right), a freelance youth sports reporter for the *Hanahan News* and father of children in the recreational programs. (COH.)

Over the years, the Hanahan Recreation Department has included numerous sports, including a youth boxing program with up to 30 boys participating any given year in the 1970s and 1980s. This 1973 photograph shows George "Barry" Barrineau receiving the Donald Flowers Memorial Sportsmanship trophy. Also pictured are, from left to right, Ralph Stanley, Hanahan recreation director, behind the ropes; Hutch Holseburg, boxer; and Mrs. and Mr. Flowers, parents of Donald Flowers for whom the award was named. Not pictured is Leon Galloway, head coach. (GBJ.)

Eight

HURRICANE HUGO

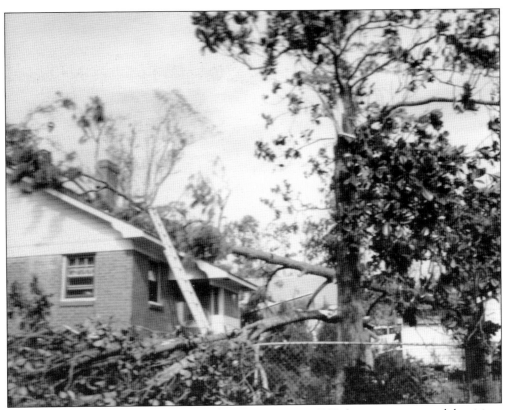

When Hurricane Hugo hit the South Carolina Lowcountry in 1989, few areas were spared the vicious wind damage. Hanahan was no exception. Although the storm surge from the ocean was centered north in the McClellanville area, the devastating winds were felt throughout the city. Pictured is former mayor Earl Copeland on top of a neighbor's roof removing limbs of a fallen tree. (BEC.)

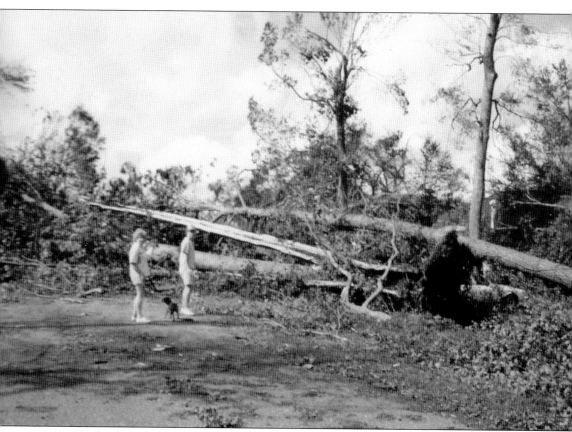

Immediately after the storm passed, there was no outside help because cleanup crews were focusing on clearing major roadways. So neighbors who were able helped neighbors who could not help themselves make the necessary emergency repairs. Pictured above are Linda Copeland (left) and an unidentified man (right) inspecting fallen trees up the street from her home. (BEC.)

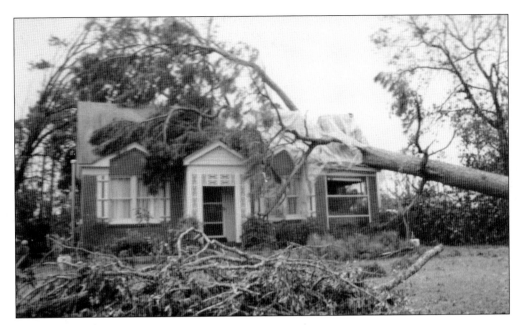

Every community in Hanahan and throughout the Lowcountry suffered similar damage from Hurricane Hugo. When outside help did finally come, it was hit and miss. All too many unqualified people who had pickup trucks became "contractors." Some came from as far away as Alabama and Mississippi. Desperate homeowners were unaware that too many of them were unethical people who were there to take advantage of unprepared homeowners. The situation was so overwhelming that the South Carolina State Contractors Licensing Board, of which former mayor Earl Copeland was a member, issued almost nonstop public service announcements warning homeowners to be sure to verify that anyone coming to their door claiming to be a contractor had a South Carolina license and a permanent business location. (Both, BEC.)

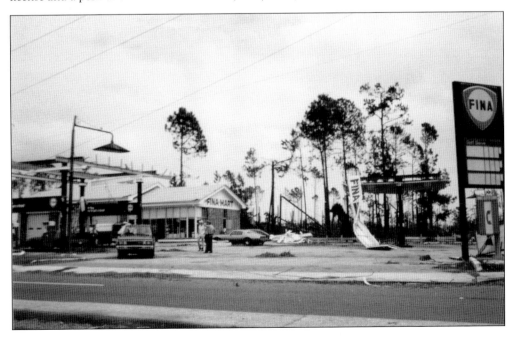

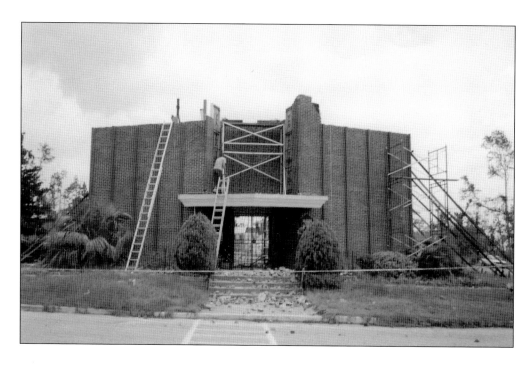

In September 1989, Hurricane Hugo ravaged the entire state of South Carolina from Charleston through the Midlands of Columbia and all the way to Charlotte. However, it came ashore as a Category 4 with the eye directly over Charleston Harbor. Hanahan was in the direct path of the eye and took blunt force winds of 150-plus miles per hour. Because Divine Redeemer Catholic Church had a flat roof, the wind peeled the roofing materials off, allowing the water to flood the interior. Nothing but the two sides of the church with the stained glass windows were salvageable. Kathy (Williams) Wright, daughter of former mayor George Williams, remembers it well. She said that the Corps of Engineers put up tents in the parking lot in which to hold Mass until the congregation was able to use the hall at the top of the hill. (Both, KWW.)

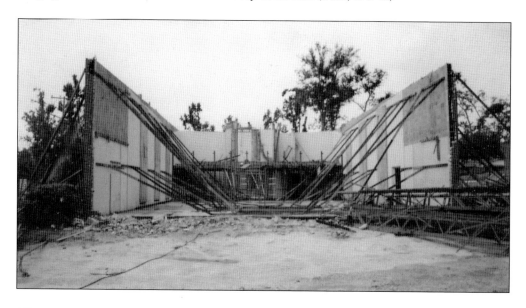

Nine

LOCAL TO NATIONAL RECOGNITION

Scotty Parker of Hanahan was seven years old when he heard about the global water crisis. It hurt his heart deeply. At his eighth birthday party, he asked for donations for Water Mission instead of gifts. Seeing he could make a difference, he asked to ride his bike across South Carolina to raise money for Water Mission for his 10th birthday. Friends and family from Hanahan rallied around him. Parker's 218-mile Ride for Water across South Carolina raised over $70,000. After seeing the impact the money made, Parker knew he had to do more. Blown away by "what God could do," in Parker's words, "with one state, imagine what he could do with a whole country." (SPP.)

At the age of 13, Scotty Parker rode his bike all the way from Santa Monica, California, to Charleston, South Carolina, 3,300 miles. He rode every mile with the first picture he had seen at the age of seven on his handlebars reminding him of his why. Kids all over Hanahan had lemonade stands raising money to help, and people donated from all over to raise roughly $630,000 for clean water and to spread hope. Parker always said he was just the kid on the bike and that it was all those people who gave that helped provide life through clean drinking water. He visited a refugee camp in Africa that received some of the funds from the ride, and a boy in a 1980s-donated Hanahan jersey ran up to him. Parker was blown away again to know how big God really is. (SPP.)

Henry E. Brown is a prominent businessman who rose to vice president of Piggly Wiggly Carolina Corporation, and at the age of 49, he retired from business to begin a life of public service. He first served on the Hanahan Planning Board. In 1981, he was elected to Hanahan City Council where he served until being elected to the State House of Representatives in 1985. Pictured above are, from left to right, councilwoman Sharon Lee, Maureen Cobb, councilman Ron Moseley, former city councilman Brown, Mayor Larry Cobb, and Hanahan administrator Anne Farley. Below, Representative Brown and his wife, Billye, were driven in a parade by James Wilkerson, owner of the vintage convertible. (Above, COH; below, MBB.)

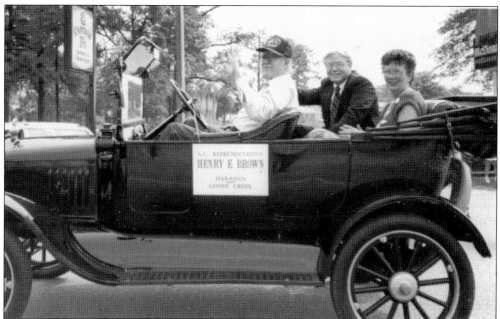

In July 1990, a group of friends gathered at the home of Berkeley Grand Old Party (GOP) chairman Earl Copeland, at which time he was presented flags flown over the state and national capitols. Among others in attendance, pictured above are, from left to right, Congressman Arthur Ravenel, state representative Henry Brown, and Berkeley County councilman Bob Call. In the background are state representative Sandi Wofford, Andy Combs, and Bud Floyd (with the hat). (BEC.)

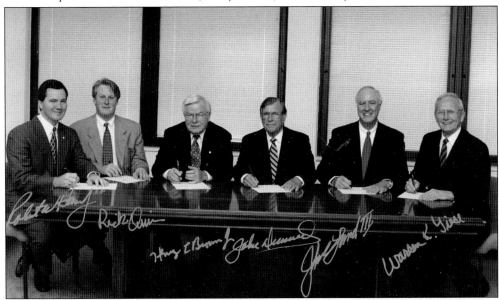

When city councilman Henry Brown was elected to the State House of Representatives in 1985, he was appointed to the House Ways and Means Committee. He later became chairman. As chairman of that committee, he had a seat on the State Budget and Control Board. Pictured are, from left to right, the six-member Senate/House Budget Reconciliation Committee: House members Bobby Harrell, Rick Quinn, and Henry Brown and Senate members John Drummond, John Land, and Warren Giese. (MBB.)

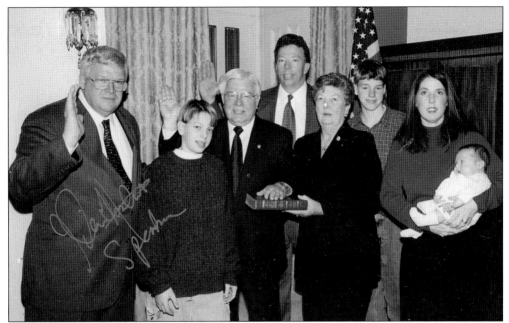

In 2000, state representative Henry Brown was elected to Congress, becoming the first Hanahan resident to earn that distinction. Pictured above, the speaker of the US House of Representatives, Dennis Hastert (left), was swearing in the new congressman, who was the oldest freshman in that Congress at age 65, while his wife, Billye, held the Bible. Looking on are, from left to right, (first row) grandson Daniel Cohl and daughter-in-law Kim (Bennett) Brown holding son Ian; (second row) son Jimmy Brown and grandson Brian Cohl. Below, Congressman Brown had opportunities such as the one pictured; here, he is in a meeting in a White House conference room with Pres. George W. Bush, Vice Pres. Dick Chaney, and others. (Both, MBB.)

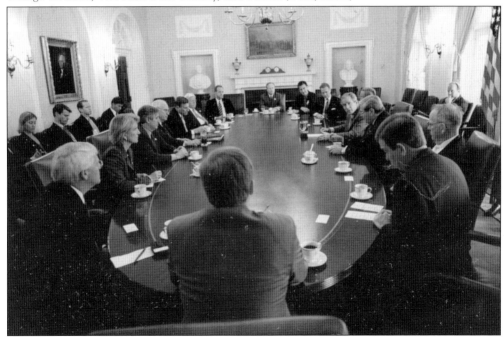

Timothy E. Scott was born September 19, 1965, in North Charleston. He grew up in a single-parent household and remembers the long hours his mom, Frances Scott, affectionately known as "Scotty," worked to provide food and shelter. Early on, Scott started on the wrong track, but his loving, faithful mother gradually got him back on a track that would later propel him to a successful life. Senator Scott currently resides in Hanahan when he is not serving on Capitol Hill. In the photograph below, he was featured alongside, from left to right, Hanahan mayor pro temp Michael Sally, Hanahan mayor Christie Rainwater, and Berkeley County supervisor Johnny Cribb. All four candidates are Hanahan residents. They appeared on the ballot of the November 2022 election and won. (Above, JMK; below, MJS, CHR.)

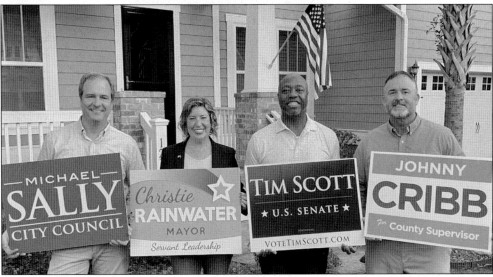

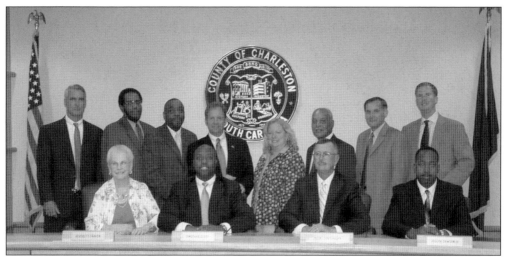

While in high school, Tim Scott met a mentor who showed him the wisdom of conservative principles. He went on to college and built his own successful small business. He set out to positively affect the lives of people. He was elected to Charleston County Council as a Republican, where he served until he was elected to South Carolina House of Representatives. Pictured above is Charleston County Council chairman Tim Scott (first row, second from left) with other council members. (MJS, JMK.)

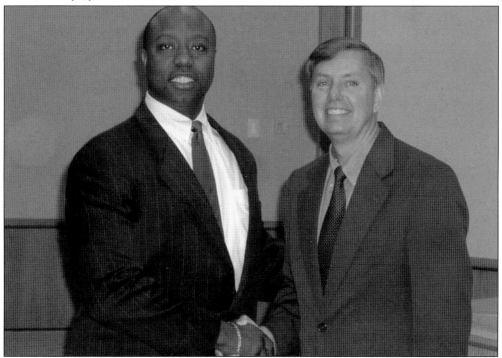

In 2010, Tim Scott was elected to the US House of Representatives. During his second term as congressman, he was appointed by Gov. Nikki Haley to fill an unexpired Senate term and then went on to be elected twice as US senator from South Carolina, becoming the first African American to be elected to that body from a Southern state since 1881. Here, Senator Scott is being greeted by South Carolina's senior senator, Lindsey Graham. (MJS, JMK.)

Daniel Dykes III (1949–2007) played playground and high school sports, graduating in 1967 from Hanahan High School. Dykes lettered in four sports at Hanahan High School and played as the center on the varsity football team. He was selected to the Shrine Bowl team his senior year (pictured at left). He received a four-year scholarship to play football for the South Carolina Gamecocks. Pictured below, Dykes, No. 70, was in the action as the Gamecock center. (RDK.)

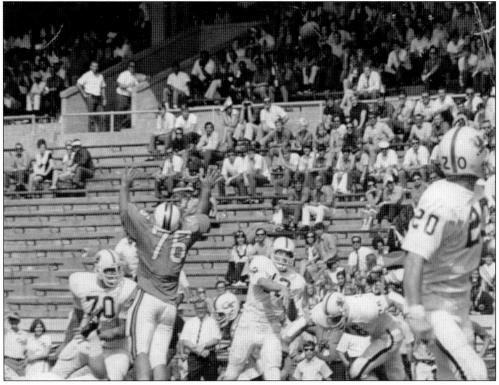

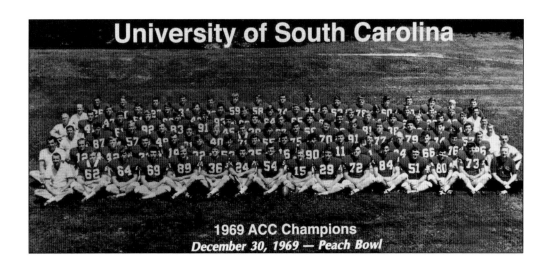

University of South Carolina

1969 ACC Champions
December 30, 1969 — Peach Bowl

Danny Dykes then continued on to play center for the University of South Carolina Gamecocks and played in the first University of South Carolina postseason bowl game, the Peach Bowl, in 1969. Upon graduation, he was drafted by the New York Jets and later played for the Buffalo Bills. Tragically, in 2007, Dykes lost a long battle with cancer. During that battle, he became a noted water paint artist who inspired thousands with his artwork. He is pictured above in a Gamecocks team photograph and below in a New York Jets team photograph. He was No. 54. (Both, EBD.)

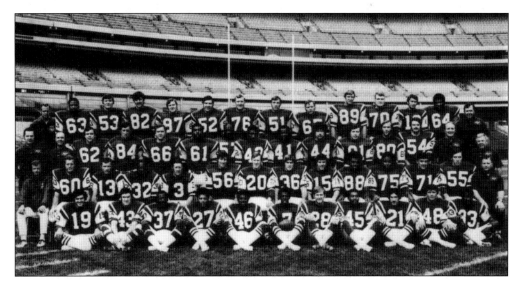

From the time that Herb Spencer was in the first grade, his father taught him football, baseball, and basketball and was his coach in recreational sports up through high school. He played Hanahan recreational sports, and in football, he played for the Bears (pictured above). He was chosen to the all-stars teams at different age levels in all three sports. The Hanahan Hawks varsity football team in his senior year of 1977 (pictured below) won the conference championship but lost 7-3 in the lower state championship game. During that season, he led the team in tackles and rushed for over 1,000 yards. (Both, HS.)

Herb Spencer accepted a scholarship to play for Newberry College in 1978. At Newberry, he was a starter from his sophomore through senior years, earning South Atlantic Conference-8 All-Conference honors, plus numerous Player of the Week awards. After college, Spencer continued to pursue a professional football career. In 1983, he signed with the New Jersey Generals of the US Football League but was traded to the Birmingham Stallions of that league the week of the season opener. While at Birmingham, Spencer was a starter all three years of the league's existence, ending his professional career as Birmingham's all-time leading tackler. Following his football career, Spencer pursued a career in sales, owning his own consulting company in Nashville, Tennessee. (Both, HS.)

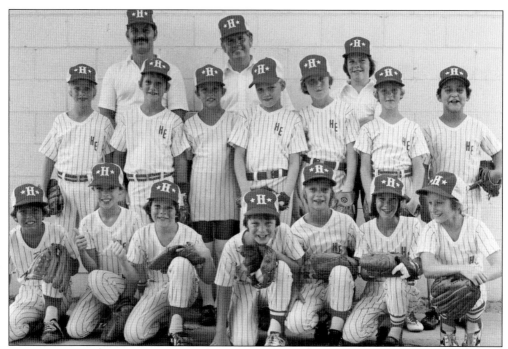

Bryce Bettencourt Florie was born in 1970 and grew up in Hanahan, where, at a very early age, he participated in Hanahan recreational sports teams. Early on, Florie showed a real talent for baseball. He was chosen to be on one of Hanahan's all-star teams (pictured above). He is in the first row at far left. He played for the Hanahan Hawks' varsity team throughout his time at Hanahan High School. Below, in the second row are head coach Bill Steadman (far left) and Florie (second from left). Florie's performance was noticed by Major League Baseball scouts, and in an almost unheard of event, he was drafted right out of high school in 1988 by the San Diego Padres. (Both, BF.)

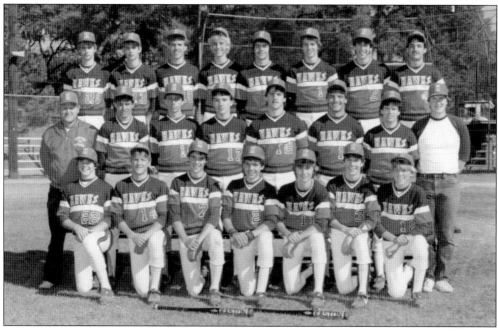

During Bryce Florie's years playing for the Hawks, coached by Bill Steadman and Doug Quinn, he racked up quite a record, both pitching and hitting. As a varsity starter, his stats were as follows: pitched 67 innings with 3 no hitters, .51 earned run average, 122 strikeouts, .485 batting average, and 7 home runs. He was also named Gatorade Player of the Year for South Carolina. Here, Florie can be seen on the mound for the Hawks. (BF.)

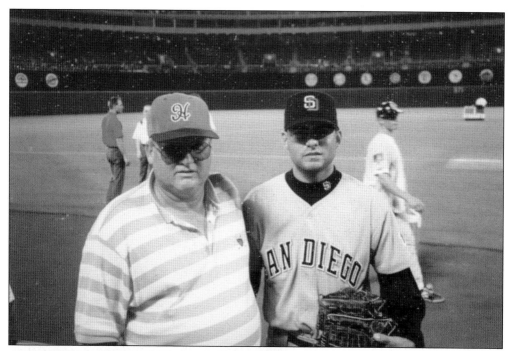

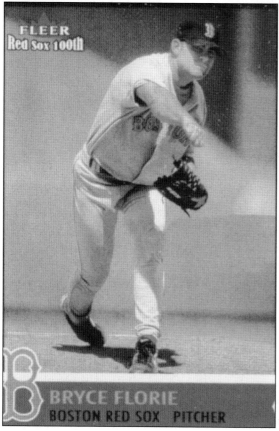

After Bryce Florie was a fifth-round draft by the San Diego Padres, he played in the minor league for a few years before moving up to the majors with the Padres in 1994. Between 1996 and 1999, he played for both the Milwaukee Brewers and Detroit Tigers. In 1999, Florie was traded to the Boston Red Sox where he had his best years. However, in a game against the New York Yankees, a line drive off the bat of a Yankee hitter caught Florie in the right eye, doing major damage and requiring extensive surgery. He returned to the mound in 2001, but after seven games, his career in the majors came to an end. The photograph above was during a visit by his Hanahan High School coach Bill Steadman at San Diego. The photograph at right is of Florie on the mound for the Red Sox. (Both, BF.)

Sports was a big part of the young life of Britt Reames, whose dad, Byron Reames, was a Hanahan High School football coach during the late 1970s and early 1980s. Reames was born August 19, 1973. He and his teammates are pictured above as eight and nine years old in 1982. Reames is in the first row, third from right. Below, playing for the Hanahan all-stars in 1985, Reames was in the first row, third from right. Reames says that he was usually the catcher in those early years. (Both, BR.)

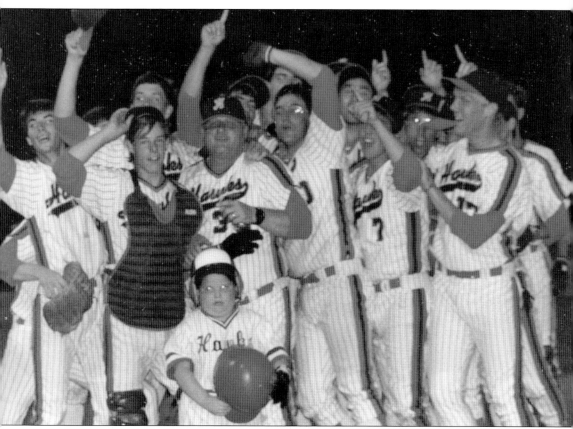

In 1988, as a freshman at Hanahan High School, Britt Reames was starting varsity catcher for the Hawks. Having just won the conference championship, Reames and teammates are shown here displaying their hands with the number one. This was Reames's last season with the Hanahan Hawks, as his dad, Hanahan football coach Byron Reames, accepted the football coaching position with Seneca High School in the South Carolina Upstate. (BR.)

According to CitadelSports.com, Britt Reames finished his career with an 18-7 record and a 2.03 earned run average, and he tied the Citadel's school record of 296 career strikeouts. He was a two-time All-Southern Conference performer in 1994 and 1995. All of this earned him a spot in the Citadel Sports Hall of Fame. Reames is seen on the Citadel mound with catcher Johnny Cribb, former Hanahan city administrator and present-day Berkeley County supervisor. (BR.)

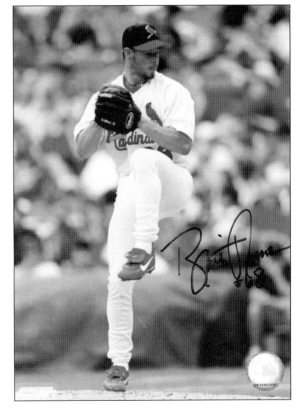

After college, Britt Reames was signed by the St. Louis Cardinals. He played with the single-A Peoria minor-league team where, in 1996, he was named Pitcher of the Year with an impressive 1.90 earned run average. After recovering from ligament surgery, Reames made his major-league debut with the Cardinals in 2000, starting seven games and managing a 2.88 earned run average. He pitched in the playoffs, giving up one run in 9.2 innings. (BR.)

DISCOVER THOUSANDS OF LOCAL HISTORY BOOKS FEATURING MILLIONS OF VINTAGE IMAGES

Arcadia Publishing, the leading local history publisher in the United States, is committed to making history accessible and meaningful through publishing books that celebrate and preserve the heritage of America's people and places.

Find more books like this at
www.arcadiapublishing.com

Search for your hometown history, your old stomping grounds, and even your favorite sports team.